Introduct

Yorkshire Traction, known throughout the company's operating area as 'Tracky', ran buses in the area of the South Yorkshire coalfield centred on Barnsley. Routes ran south to Sheffield, north to Huddersfield, Wakefield and Leeds, west towards Manchester and east as far as Doncaster.

During my childhood years I was brought up just outside the boundaries of the latter town, on Sprotbrough Road, served by 'Tracky' routes 13, 21 and 49, or variants thereof. I came to know the company's buses very well.

Yorkshire Traction's history began in 1902, when the Barnsley & District Electric Traction Company, a subsidiary of the British Electric Traction Company (BET), began operating trams. The operations only ever consisted of one main route, from Smithies in the north, through Barnsley town centre and south for another two miles, where it split into two, serving both Worsborough Bridge and Worsborough Dale.

Other areas of Barnsley also demanded public transport, so Barnsley & District began to provide motorbuses, gradually expanding the network to become the dominant operator. Because the tramway had become only a minor part of the company's operation, the word 'Electric' was dropped from its title in 1919. More expansion saw buses reach many other parts of southern Yorkshire, so again the company changed its name to become Yorkshire Traction in 1928. Trams ceased operation in 1930.

Barnsley was also served by another tramway, that of the Dearne District Light Railway. This was quite a latecomer to the scene, not opening until 1924. Its westerly terminus was a location just outside Barnsley town centre, where it met the Barnsley & District tracks, but with no physical connection – thus passengers were obliged to change or walk into town. From Barnsley it ran along through populous Dearne Valley towns to Goldthorpe, Thurnscoe, Manvers Main and the Woodman Inn at Swinton. Throughout its short life, the Dearne District Light Railway suffered from road competition and eventually succumbed in 1933. The 'Car Barns' at Wombwell became Yorkshire Traction's depot. Similarly, the former tram shed of Barnsley & District on Upper Sheffield Road became Yorkshire Traction's main depot, workshops and headquarters.

Yorkshire Traction's vehicle purchasing policy from the 1930s onwards was to buy Leyland buses, with a few exceptions, such as a batch of Dennis saloons in the post-war years. However, a good number of more obscure buses and coaches entered the fleet during the many takeovers of most of the Barnsley area independents, including a Foden and a Sentinel. The businesses purchased included Camplejohn of Darfield, Burrows of Wombwell and Rowe's of Cudworth, to name just a few.

It was a logical move to absorb two smaller companies, Mexborough & Swinton and County Motors. The former was originally a tramway operator, based at a depot in Rawmarsh. Trams began running in 1907 and continued until 1929. At its greatest extent, the route ran from Rotherham to Denaby (Old Toll Bar). It was here that an obstacle was encountered. The Great Central Railway was unwilling, understandably, for tram lines to cross the main line railway tracks on the level, so Mexborough & Swinton began running a trolleybus service onwards to the sizeable communities of Denaby Colliery Village and Conisbrough in 1915. Eventually, the majority of the Mexborough & Swinton routes were converted to single-deck trolleybus operation. This continued until 1961, from when only motorbuses were operated. Mexborough & Swinton, its Rawmarsh depot and all vehicles were transferred to Yorkshire Traction in 1969.

County Motors was founded in 1919, running from Huddersfield to Lepton. By 1927, the company had services into Dewsbury and Wakefield, but had passed to a joint enterprise consisting of Yorkshire Woollen District, Yorkshire Traction and the West Riding Automobile Company. With the latter being an independent concern, County Motors remained a separate entity, the other two operators being BET subsidiaries. However, foreseeing the future, West Riding sold out to the Transport Holding Company in 1967. The same fate befell all BET operators in 1968 and, therefore, County Motors was passed to Yorkshire Traction ownership. All vehicles were absorbed into the 'Tracky' fleet, including a few Guy Arab double-deckers.

The first day of January 1969 saw Yorkshire Traction become part of the National Bus Company (NBC). It was not long before NBC's corporate policies were implemented, with buses being painted into all-over poppy red. Leyland Nationals and Bristol VR types became standard throughout England and Wales, including the 'Tracky' fleet.

As deregulation and privatisation loomed, the NBC became more relaxed about liveries and more traditional styles began to reappear. The old underscored fleet name was reintroduced. 1986 saw deregulation come into effect and soon competition from many small independent operators was making itself felt, especially in Barnsley and Sheffield.

Yorkshire Traction was sold on the first day of 1987, to a management buyout. Gradually, new buses were acquired, with a striking enough white-based colour scheme being applied. Competition began to be eliminated by purchasing the many smaller companies, consolidating them into the likes of Yorkshire Terrier and Barnsley & District.

Meanwhile, the Yorkshire Traction Group had expanded with the purchase of Lincolnshire Road Car Company in 1988 and Scottish operator Strathtay in 1991. These are outside the scope of this publication, but do get a mention or two due to vehicle transfers within the group.

December 2005 saw the entire Yorkshire Traction Group being sold to Stagecoach, who soon imposed that company's corporate livery onto each bus. At the time of writing in 2017, very few former Yorkshire Traction buses remain in service and it will not be long before the company is just a memory in the minds of the good people of the South Yorkshire coalfield.

Many thanks are due to Bus Lists on the Web, the late Les Flint, Richard Huggins, Jim Sambrooks, Bob Telfer and Peter Tuffrey for help in the preparation of this book.

YORKSHIRE
TRACTION BUSES

JOHN LAW

AMBERLEY

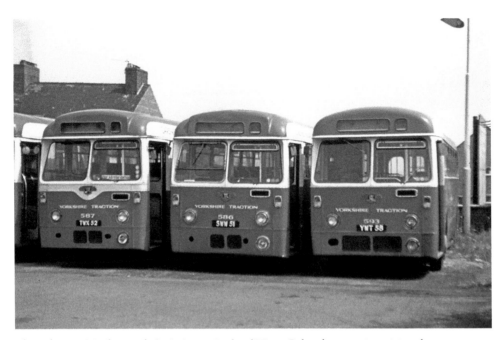

Three former Mexborough & Swinton Leyland Tiger Cub saloons, 587, 586 and 593, are seen withdrawn at Wombwell depot.

First published 2018

Amberley Publishing
The Hill, Stroud
Gloucestershire, GL5 4EP

www.amberley-books.com

Copyright © John Law, 2018

The right of John Law to be identified as the Author of this work has been asserted in accordance with the Copyrights, Designs and Patents Act 1988.

ISBN 978 1 4456 6969 4 (print)
ISBN 978 1 4456 6970 0 (ebook)

British Library Cataloguing in Publication Data.
A catalogue record for this book is available from the British Library.

Typesetting by Amberley Publishing.
Printed in the UK.

Barnsley & District

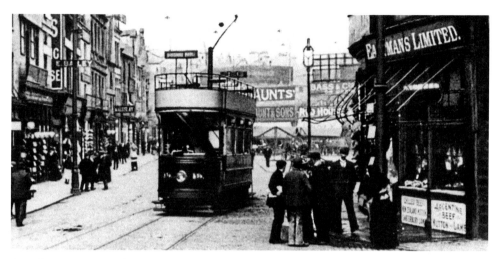

Barnsley & District Electric Traction Company (a subsidiary of the British Electric Traction Company) began operating tramways in the town in 1902. Only one route was constructed, from Smithies in the north, through central Barnsley and along the Upper Sheffield Road, after which the service split, with some trams going to Worsborough Bridge and the others to Worsborough Dale. A small fleet of open-top four-wheel cars was purchased, such as No. 19, seen in Cheapside, Barnsley town centre.

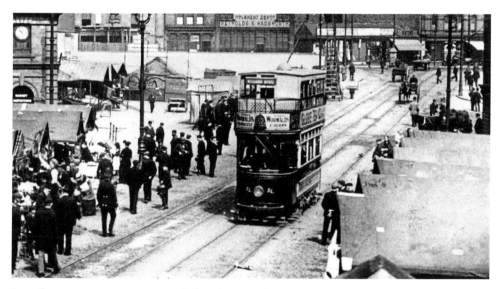

Barnsley's trams were soon provided with covered tops, as demonstrated by car No. 8, passing along a short double-track section in Mayday Green, in the town centre. Most of the Barnsley tram network was single-track, with passing loops at frequent intervals. Tramway operation ceased in 1930.

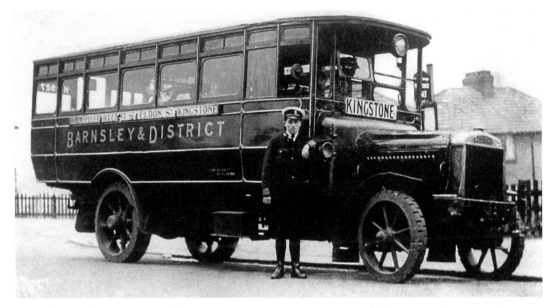

The Barnsley & District Electric Traction Company soon expanded into motorbus operation, commencing in 1913. Early deliveries of buses were from Leyland Motors, an example of which is seen here in the Barnsley suburb of Kingstone. This is a Leyland N type, fleet number 46 (HE 927), with twenty-eight-seat bodywork built by Brush. It had been new in 1921 and had departed by 1928. Thanks to Bob Telfer for supplying the information regarding the early buses of Barnsley & District.

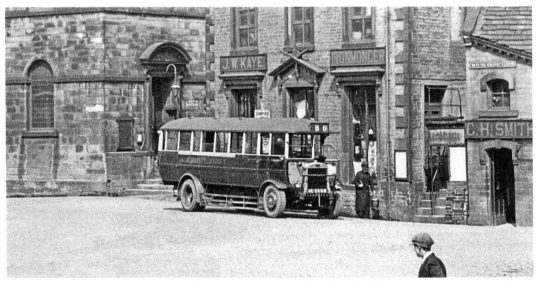

Barnsley & District, as displayed on the bus, later purchased Leyland Lion PLSC1 types, one of which, No. 143 (HE 2808), is seen in Victoria Square, Holmfirth. The vehicle's bodywork is by Brush, with a centre entrance and seating thirty passengers. This bus, one of twenty-one similar buses, was new in 1926 and withdrawn in 1933, dating the photograph to around 1928. In that year, with considerable expansion of the operational area, the decision was made to rename the company as Yorkshire Traction. Thanks to Peter Tuffrey for supplying this photograph.

Pre-National Bus Company Days

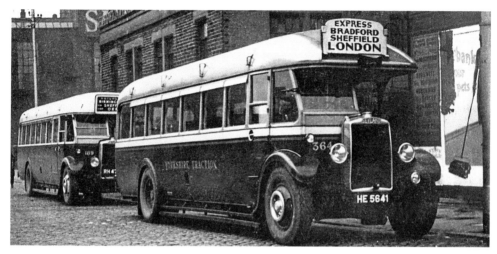

Displaying its Yorkshire Traction fleet name is No. 364 (HE 5641), built in 1932. This Leyland Tiger TS4 with a Weymann body fitted with coach seats is seen in Sheffield, on the long-distance express route to London. It is connecting with a similar vehicle of East Yorkshire Motor Services en route from Hull to Birmingham. By the time of this photograph, around 1935, Yorkshire Traction had joined forces with other operators to form the 'Yorkshire Services' group of coordinated long-distance routes. (John Law Collection)

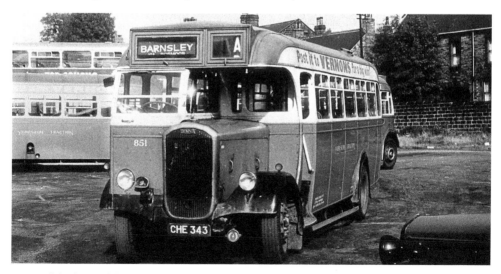

Most of the buses delivered to Yorkshire Traction were of Leyland manufacture, but twenty-four Dennis Lancet III buses were delivered in 1950. One of these, No. 851 (CHE 343), bodied by Brush and seating thirty-two passengers, is seen in the yard of the company's main depot at Upper Sheffield Road, Barnsley, probably in the early 1950s. It has not been possible to ascertain who took this photograph, but if the copyright holder comes forward, a copy of this book will be provided.

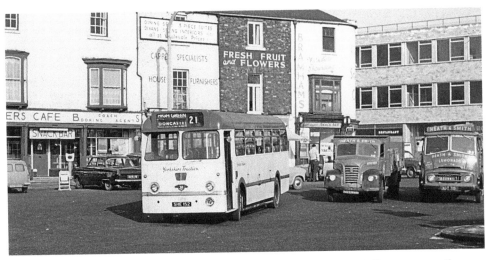

Many of Yorkshire Traction's services used Waterdale as the terminus in Doncaster until a new bus station at Glasgow Paddocks was opened just over the road. The original terminus continued in use as a parking area and by long-distance express services. Laying over here on 25 February 1966 is fleet number 1164 (SHE 152), one of twenty-three Metro-Cammell-bodied Leyland Tiger Cubs delivered in 1960. Though it is painted in a livery normally reserved for coaches, it has forty-five bus seats. At the time, several cafés along Waterdale catered for passengers needing refreshment and, no doubt, the two Heath & Smith lorries are delivering mineral waters to the various establishments. Photograph by the late Les Flint.

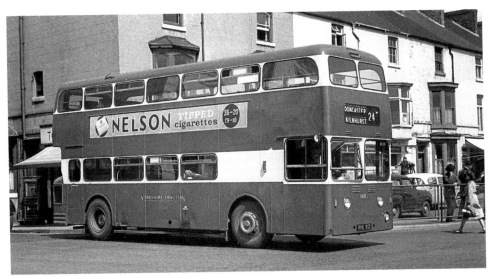

Yorkshire Traction received its first rear-engined buses in 1959 in the form of a dozen Leyland Atlantean PDR1/1 vehicles, the last of which numerically was 1162L (RHE 812). The 'L' suffix indicated that it was a low-height bus, suitable for negotiating certain bridges under railways in the area. Having just come from Kilnhurst on service 24, it would have had to negotiate the bridge under the former Midland Railway at Swinton Town station. All this batch of buses carried seventy-three-seat bodywork by Weymann. Les Flint took this photograph, around 1961, as the bus left Young Street in Doncaster and was about to cross Waterdale and enter Glasgow Paddocks bus station.

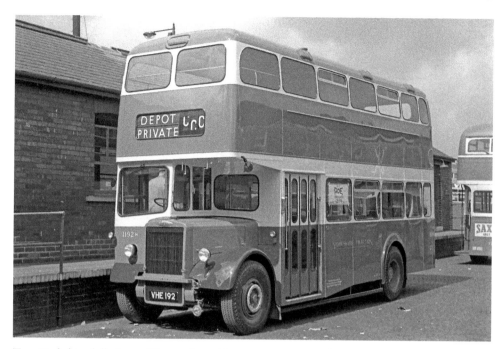

True Yorkshire folk do not like parting with money unnecessarily (and that includes the author). Therefore, when Yorkshire Traction decided that some Leyland Tiger PS2 chassis were too good to throw away, they would be rebodied as double-deckers. Roe was given the contract for five of these and here is No. 1192 (VHE 192), newly delivered from the Crossgates factory, at Barnsley depot in 1961. The chassis of this bus had been new as a Windover-bodied thirty-two-seater numbered 902 (CHE857), built in 1950.

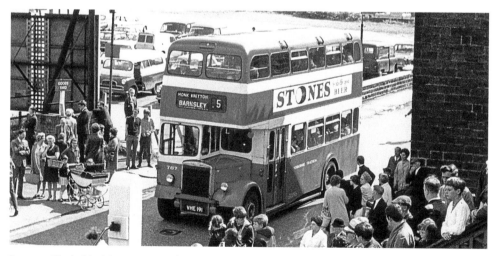

In 1967, Yorkshire Traction introduced a new livery and numbering scheme. Previously No. 1191 (VHE 191), sister to the above, this bus has now been given fleet number 787 and its new coat of paint as it waits for the level crossing gates at Jumble Lane, beside Barnsley bus station, in 1967. The large number of bystanders are not here to see the bus, but the world-famous steam locomotive *Flying Scotsman*, which was just about to depart from Barnsley Exchange station with a southbound special. Les Flint took both photographs on this page.

Companies Taken Over

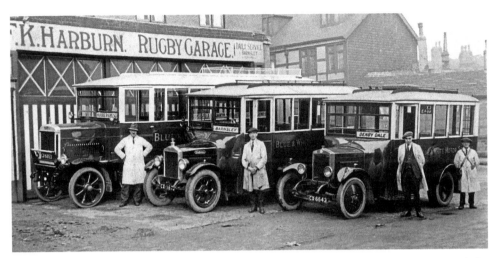

Even in the days of Barnsley & District, expansion had begun with the takeover of the stage services of Blue & White of Fartown, Huddersfield, in April 1925. The proprietor, Frank K. Harburn, ran services from Huddersfield towards Barnsley, as displayed on the destination boards of these fine vehicles seen at the company's headquarters. On the left is a Leyland, CX 6853; next comes a rare Gotfredson built in 1924, while a sixteen-seat Berliet, registered CX 6643, is closest to the camera.

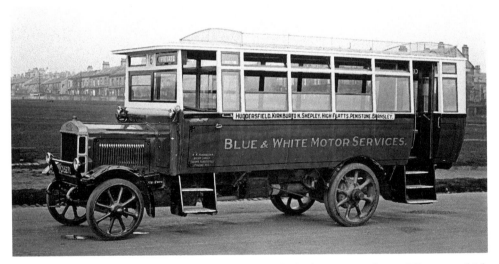

Adding variety to the Blue & White fleet is this locally built Karrier saloon, CX 5271, which is seen posing for the camera in Huddersfield. At a maximum speed of 12 miles per hour, it would have taken quite a long time to travel the entire route from Huddersfield to Barnsley via Penistone. After selling his bus services to Barnsley & District, Mister Harburn continued to operate coaches until 1933. Thanks to Peter Tuffrey for supplying these photographs.

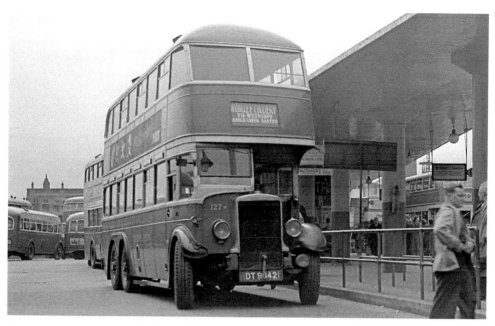

The post-war years saw Yorkshire Traction continue to purchase local independents. One of these was Cawthorne's, from the Barnsley area, in 1952. Two double-deckers were acquired; one was a Foden, but the other was DT 9642, a rare 1938 Roe-bodied Leyland Titanic three-axle 'decker, new to Doncaster Corporation. Despite being used for only around a year by Yorkshire Traction, it received a fleet number – 127H – and was painted into the current livery of the time, as seen in Barnsley bus station in 1952. (Les Flint)

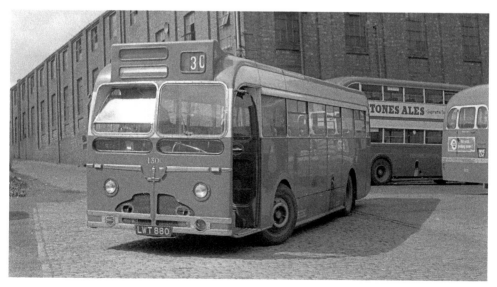

The business of Camplejohn of Darfield was sold to Yorkshire Traction on the first day of 1961, bringing a variety of vehicles into the fleet – not one of which was a Leyland! With the purchase came LWT 880, an all-Sentinel STC6 forty-four-seat saloon. It is seen here, in its new colours, bearing fleet number 130C (the suffix just meaning 'Camplejohn') at Barnsley depot, in around 1961. It was withdrawn in 1963. (Les Flint)

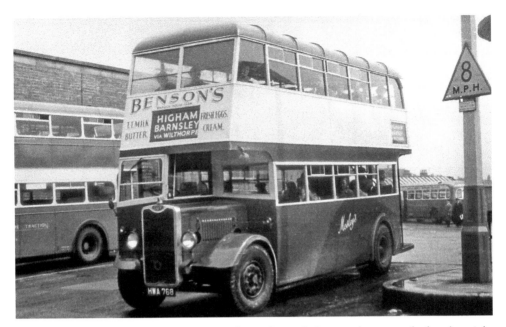

Another Barnsley area independent was Mosley's of Barugh Green, who succumbed to the might of Yorkshire Traction in 1965. Leaving Barnsley bus station in 1957 is this fine Guy Arab II, registered HWA 768. Carrying a 'utility' Weymann body, it had been new to Sheffield Joint Omnibus Committee in 1943. (John Law Collection, original photographer unknown)

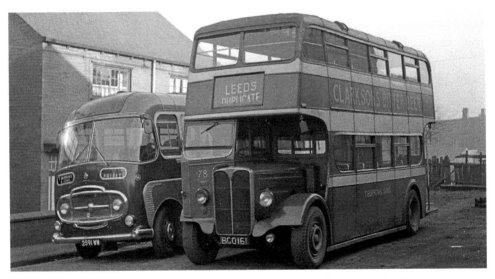

Burrow's of Wombwell was a sizeable independent operator known for its frequent services between Barnsley, Wakefield and Leeds. Yorkshire Traction purchased it in October 1966, though no Burrow's vehicles were to enter the 'Tracky' fleet as they mostly consisted of rather antiquated AEC buses. One such was No. 78 (BCO 161), an AEC Regent that had been new to London Transport (No. STL1246) as early as 1936. Burrow's had bought it in 1953 and fitted it with a Roe body that had previously been carried on another AEC. Seen alongside is coach No. 96 (2591 WW), a 1960-built Bedford SB1 with forty-one-seat Plaxton bodywork, which would have been virtually new when photographed at the depot. (Les Flint)

County Motors

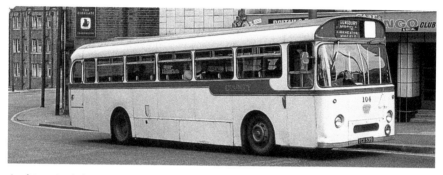

At this point it is appropriate to include a small section about County Motors (Lepton) Ltd. The company had begun in 1919, operating one route out of Huddersfield. Expansion followed, with Wakefield and Dewsbury then being reached. In 1927, the business was sold to two BET companies, Barnsley & District along with Yorkshire Woollen District, plus one large independent, West Riding. Due to this unusual combination of owners, County Motors was kept as a separate entity for many years. Typical of the fleet in the 1960s was this Leyland Leopard with fifty-three-seat Willowbrook bodywork, No. 104 (YCX 539), which was photographed by Les Flint as it passed the Kirkgate pub on entry into Huddersfield town centre in June 1968.

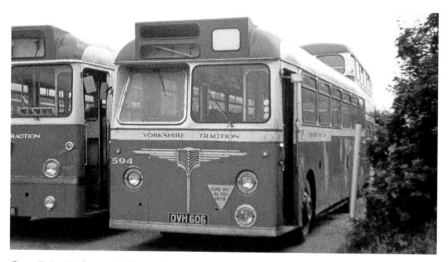

Once Britain's largest independent, West Riding had sold out to become a nationalised concern, and in 1968 it was decided that County Motors would become part of the Yorkshire Traction operation. The more standard buses within the County Motors fleet were swiftly repainted into the red 'Tracky' colours. These have been applied to Yorkshire Traction No. 594 (OVH 606), which is seen having been recently withdrawn at Barnsley depot. This Leyland Tiger Cub/Willowbrook saloon had been new to County Motors as No. 95 in 1960. Further ex-County Motors buses will appear elsewhere within these pages.

Mexborough & Swinton

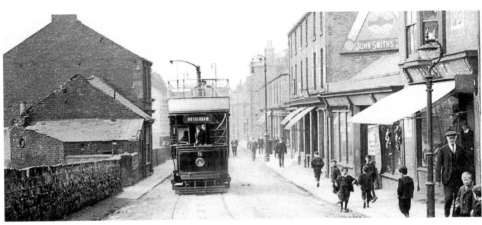

Although a tramway connecting Rawmarsh to Rotherham was proposed as early as 1876, nothing happened until 1905, when construction began on the Mexborough & Swinton system. Connecting with the Rotherham Corporation tram network, the line ran through Rawmarsh, Swinton and Mexborough to Denaby (Old Toll Bar), where the line terminated as it was unable to cross the Great Central Railway on the level. The trams operated on the Dolter stud contact system, which car No. 8 is using in central Mexborough. The idea of this means of current collection was that the car would always be in contact with a stud that would only be live as the tram passed over. In practice, many a horse, dog or mischievous boy found out that this was not always the case!

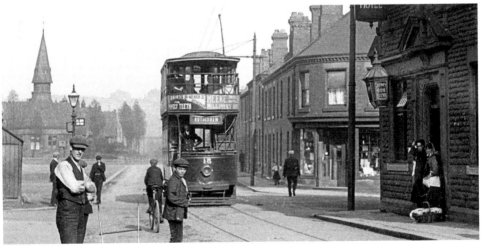

Because the Mexborough & Swinton cars were fitted with poles for traction current collection when working over the Rotherham system, it was a fairly simple exercise to convert to overhead line operation, which commenced in 1908. It also allowed Rotherham trams access to the Mexborough system. Mexborough & Swinton car No. 13, one of the original trams built in 1907, but later fitted with a covered top, is seen in Bridge Street, Swinton, with the unmistakeable Swinton Bridge School seen on the left.

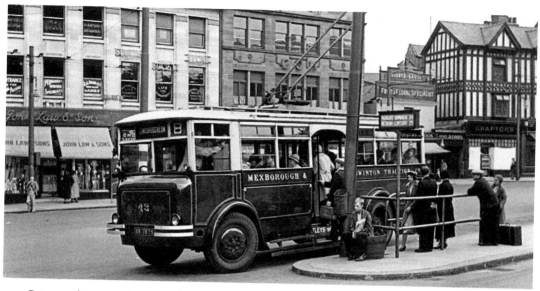

Between the years of 1925 and 1929, the Mexborough & Swinton system began to be converted to trolleybus operation. The year 1931 saw the business become part of the British Electric Traction Company, who already owned Barnsley & District. Seen here in Bridgegate, Rotherham, is trolleybus No. 43 (WW 7875), a 1928-built Garrett O type with Garrett centre-entrance bodywork seating thirty-two passengers. This vehicle would last until withdrawal in 1948, probably just after this photograph was taken. It should be noted that the shop seen in the left of the picture, John Law & Sons, has no connection with the author of this book!

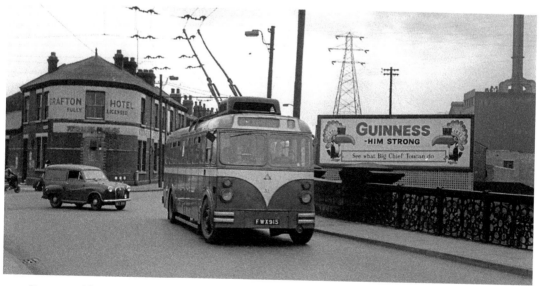

Because of low bridges, the Mexborough & Swinton trolleybus fleet consisted entirely of single-deck vehicles. Typical of these was No. 31 (FWX 915), a Sunbeam F4 with thirty-two-seat, centre-entrance Brush bodywork. Built in 1948, it survived until the system closed in 1961. Outward bound for Mexborough, it is seen crossing the River Don and passing the Grafton Hotel, a William Stones house, on St Anns Road in Eastwood, on the edge of Rotherham town centre. The town's power station is behind the toucan-featuring Guinness advert.

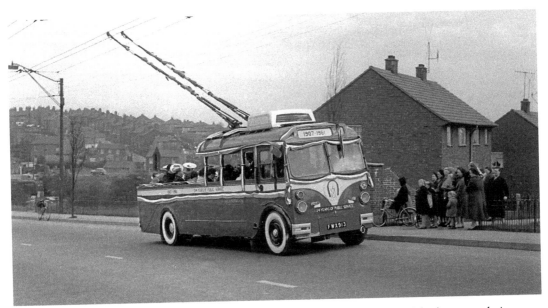

Mexborough's trolleybuses ceased operation on 26 March 1961, with the event being commemorated by a procession of vehicles heading for the depot at Rawmarsh. Included in the formation was trolleybus No. 29 (FWX 913), another of the 1948 batch. It had been cut down and decorated especially for the occasion, and is seen carrying various dignitaries and a brass band. Watched by a small crowd of locals, it is about to enter the depot yard.

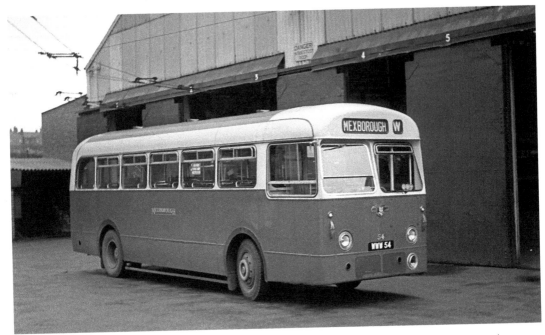

Mexborough & Swinton purchased a sizeable number of Leyland Tiger Cub saloons to replace the trolleybuses, one of which, No. 54 (WWW 54), was photographed outside Rawmarsh depot in around 1961. Carrying a forty-one-seat Weymann body, it had been new in 1959. Ten years later, it passed into the main Yorkshire Traction fleet, where it became fleet number 589.

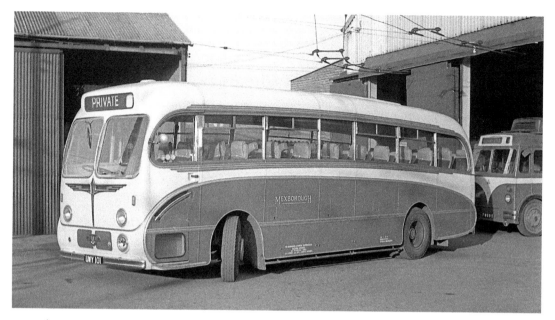

The company also operated a small fleet of coaches, such as No. 101, a 1958-built Leyland Tiger Cub with forty-one-seat Burlingham 'Seagull' bodywork. Here, it is seen posed outside the main depot, Rawmarsh, in around 1961.

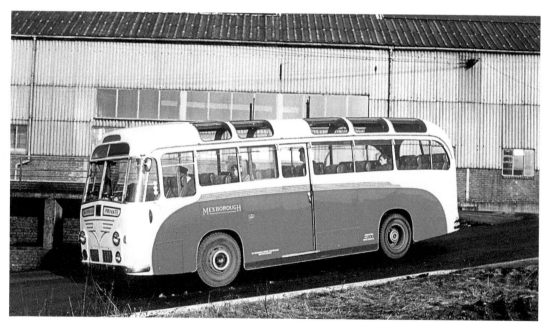

The later years of Mexborough & Swinton saw a number of second-hand vehicles being purchased. Several came from fellow BET operator Southdown Motor Services, such as No. 103 (OUF 834), which is seen at Rawmarsh depot in around 1966. New to Southdown in 1955 as No. 1834, this Leyland Tiger Cub with centre-entrance Harrington coachwork seated only twenty-six passengers. It was finally withdrawn in 1968, a year before Mexborough & Swinton was absorbed into the Yorkshire Traction Company. (Les Flint)

Dearne District Light Railway

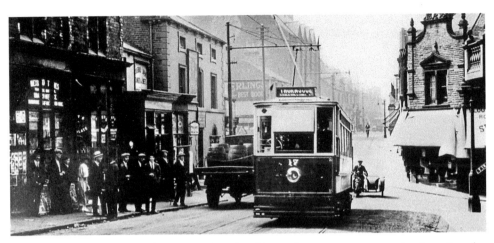

The Dearne District Light Railway was a short-lived interurban tram system running from Barnsley to Thurnscoe via Wath-upon-Dearne, with branches to Manvers Main Colliery and the Woodman Inn at Swinton. Opening in 1924, it struggled to make a profit and suffered from competition from local buses, which were able to penetrate central Barnsley. The fleet consisted of thirty single-deck cars built by English Electric at Preston, each seating thirty-six passengers. Here we see car No. 17 passing through the High Street in Wombwell, hotly pursued by a motorcycle and sidecar.

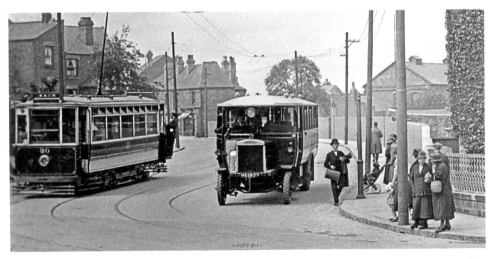

Numerically the last car in the Dearne District fleet, No. 30 is seen in Montgomery Road in Wath. It appears to be working wrong line, but has probably terminated in the town and is about to reverse, as the conductor is closely examining the actions of the trolley-head. Passing by is the competition, Barnsley & District bus No. 98 (HE 1827). This Brush-bodied Leyland SG7, new in 1924, was withdrawn in 1929, so that dates the photograph to the mid to late 1920s. The Dearne District system closed at the end of September 1933, with the 'car barns' (an American term for depot) in Wombwell becoming Yorkshire Traction's depot.

National Bus Company Ownership

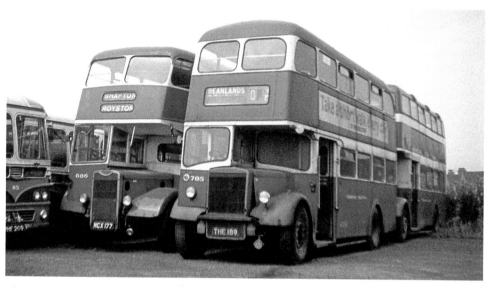

The first day of January 1969 saw the formation of the National Bus Company, of which Yorkshire Traction became a subsidiary. As we have seen, County Motors was immediately absorbed, with Mexborough & Swinton following in the same year. Otherwise, things did not change too much, with the livery and fleet numbering system continuing. At Shafton depot in the early 1970s we see No. 785 (THE 189), a Leyland PS2/3 rebuild that had been given a new Northern Counties body in 1960. Alongside is ex-County Motors No. 686 (NCX 177), a Roe-bodied Guy Arab IV.

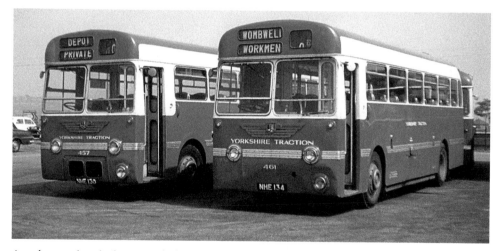

Another undated photograph, but from the early 1970s, at Wombwell depot yard, shows perfectly the last livery style applied to Yorkshire Traction buses. No. 457 (NHE 130) and sister vehicle No. 461 (NHE 134) were both part of a batch of twenty-two Park Royal-bodied Leyland Tiger Cubs that were delivered in 1958 and originally numbered 1123 and 1127 respectively.

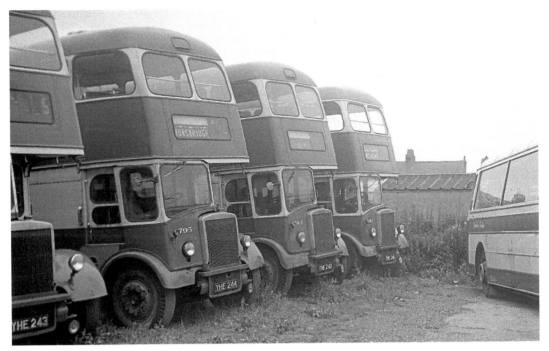

By 1973, many of the Leyland PS2/3 rebuilds had been withdrawn. In this picture taken in that year, three (Nos 795, 793 and 792) are seen dumped in the yard of Upper Sheffield Road depot in Barnsley. Most would go to one of the nearby scrapyards, though a sister vehicle, No. 791 (YHE 240), saw further service with Smith of Patna, Scotland, and survived well into the 1980s.

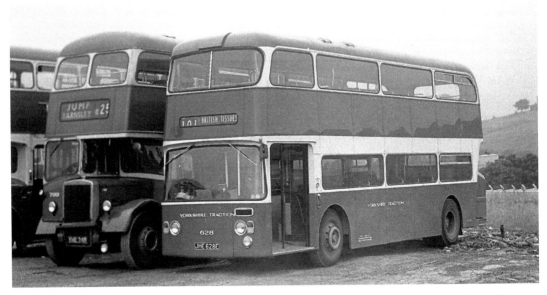

Also seen in the yard at Barnsley depot in 1973 was Yorkshire Traction No. 628 (JHE 628E). This Leyland Atlantean AN68/1R with Northern Counties seventy-five-seat bodywork had been new in 1967. Despite it being parked alongside another PS2/3 rebuild (No. 699), No. 628 had a long life in front of it and was not withdrawn until the early 1980s.

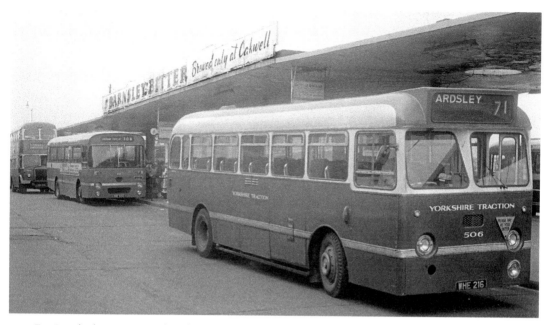

During the late 1950s and early 1960s, the Leyland Tiger Cub became the standard single-deck bus in the Yorkshire Traction fleet. One of the 1962 batch, No. 506 (WHE 216), with an Alexander forty-five-seat body, is seen in Barnsley bus station in 1974. Its original fleet number was 1216, prior to the renumbering scheme of 1967. Behind is a Leyland Leopard newly painted in NBC livery, plus one of the PS2/3 rebuilds that were still in service. Above is an advert for the famous Barnsley Bitter, brewed nearby at Oakwell.

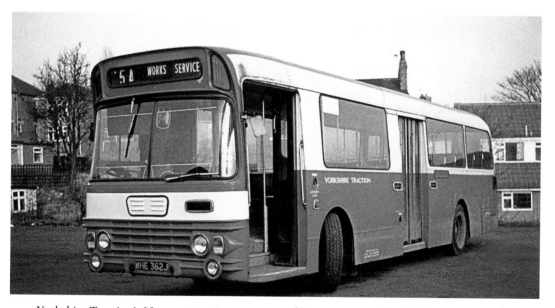

Yorkshire Traction's Nos 357 to 365 were unusual in two aspects. Firstly, they were Daimler Fleetlines – single-deckers – and, secondly, they were the only dual-doorway buses in the fleet. Forty-five-seat bus No. 362 (WHE 362J) was photographed in its original livery by Jim Sambrooks, in the depot yard at Rawmarsh, in February 1973.

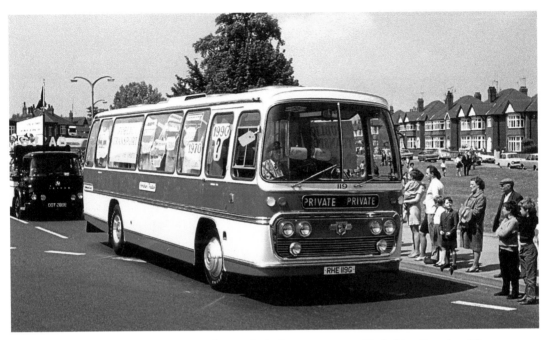

Taking part in Doncaster's 'Impel' parade in June 1970 was Yorkshire Traction No. 119 (RHE 119G), a forty-five-seat Leyland Leopard/Plaxton coach that was new to the company in the previous year. It is being watched with enthusiasm by the locals as it approaches the racecourse. (Les Flint)

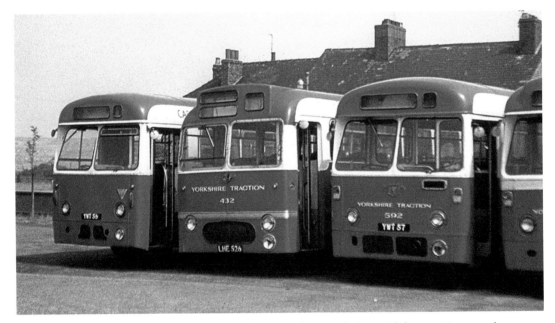

By the early 1970s, many of the Leyland Tiger Cubs were being withdrawn. Here are three, which have been dumped in the yard at Wombwell depot. In the centre is No. 432 (LHE 526), a 1957 example with forty-four-seat Willowbrook body. Ex-Mexborough & Swinton Weymann-bodied saloons Nos 591/2 (YWT 56/7) make up the rest of the trio.

Now we are at Shafton depot sometime around 1974. Inside are various buses, now in NBC red, but outside, in the sun, is No. 6 (CHE 305C), which is still in its later 'Tracky' livery. Delivered in 1965 as fleet number 1305, this Leyland Leopard has a forty-nine-seat Plaxton 'Panorama' body.

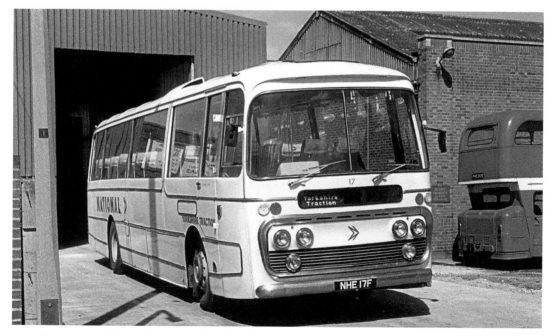

Having been delivered after the Yorkshire Traction renumbering scheme, No. 17 (NHE 17F) still carried that identification when photographed in brilliant sunshine in 1977, again at Shafton depot. Though it had been new three years after the coach shown in the previous photograph, both coaches were virtually identical, although this one has now received NBC white livery.

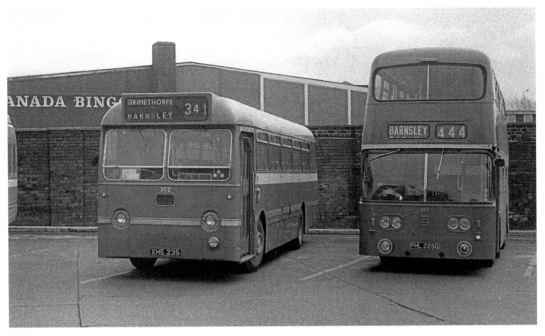

Yorkshire Traction bought many BET-style Leyland Leopard service buses over the years. The first batch was delivered in 1962 with Willowbrook fifty-four-seat bodywork and featuring four-piece windscreens. New as No. 1235, XHE 235 is seen in the mid-1970s as No. 302, which is resting a while at Barnsley bus station alongside West Riding Daimler Fleetline No. 660.

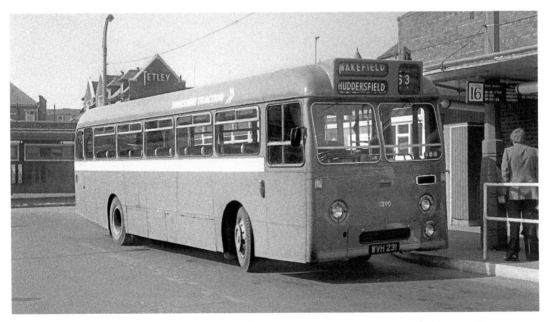

Following the vehicle purchase policies of its parent companies, it was inevitable that County Motors would also receive some four-piece windscreened Leyland Leopards. Another 1962 delivery was that of WVH 231, No. 102 in the County fleet, but seen here as No. 390 in 'Tracky' NBC colours at Wakefield bus station, in around 1974.

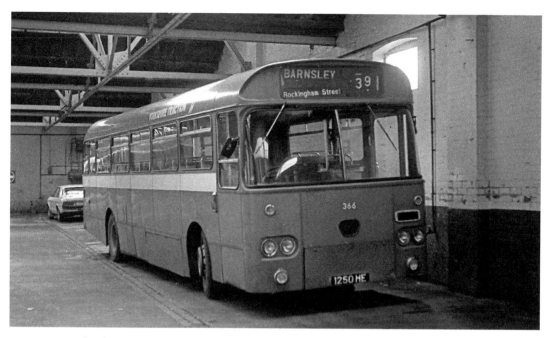

More Leyland Leopard saloons were received in 1963, including No. 1250 (1250 HE) – this time with the more conventional curved windscreen. Originally a dual-purpose vehicle, it is seen inside Barnsley depot in around 1977, having been downgraded to a service bus and with fleet number 366.

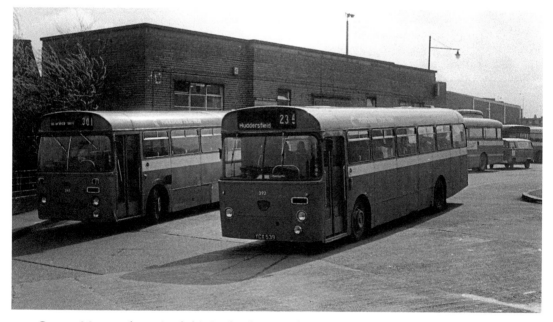

County Motors also gained this Leyland Leopard in 1963. Like the above vehicle, it has a Willowbrook body, this one seating fifty-three passengers. Delivered as No. 104, YCX 539 is photographed leaving Barnsley bus station as Yorkshire Traction No. 392. It is passing No. 397 (GVH 213D), another former County Motors Leyland Leopard, this time with Marshall bodywork. The photograph was taken in around 1977.

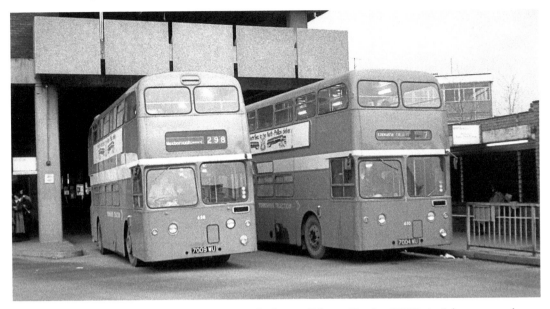

Yorkshire Traction, as we have already seen, had a small fleet of Leyland PDR1/1 Atlanteans and inherited some more when Mexborough & Swinton was absorbed. Two of these, still in their original operating area, at Rotherham bus station, are seen in 'Tracky' hands in around 1974. On the left is No. 688 (7009 WU), with 'lowbridge' Weymann seventy-two-seat bodywork, heading out for Mexborough, while sister bus No. 680 (7004 WU) is loading up for a Rawmarsh Circular. They were originally Nos 9 and 4 respectively in the Mexborough fleet.

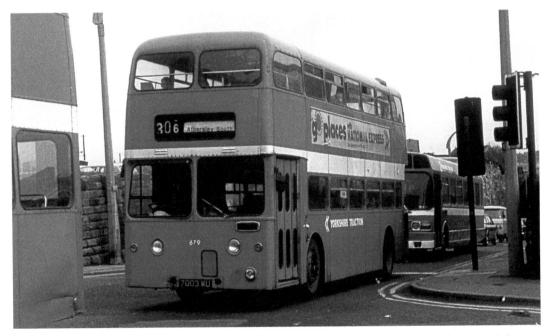

At least some of the former Mexborough Atlanteans saw further action beyond their erstwhile home territory. No. 679 (7003 WU) has migrated to distant Barnsley and was captured on film approaching the bus station from the north, along Eldon Street, in 1977.

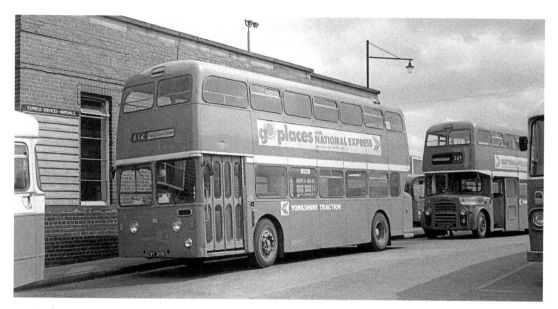

When new in 1964, Mexborough & Swinton No. 19 (CWY 319B) became the only Daimler Fleetline in that fleet. With a seventy-seven-seat Weymann body, it was to remain unique, though other Fleetlines were later obtained. In its later guise as Yorkshire Traction No. 751, it is seen in Barnsley bus station, in around 1977.

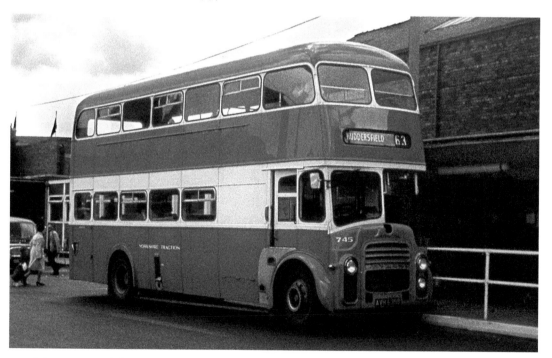

More 1964 deliveries saw County Motors receive a pair of Roe-bodied Leyland PD3A/1 double-deckers, Nos 105 and 106 (AVH 635/6B). They were to become Yorkshire Traction Nos 745 and 746. The first of that pair is seen at Wakefield bus station, on a service to Huddersfield, still in its pre-NBC livery in around 1972.

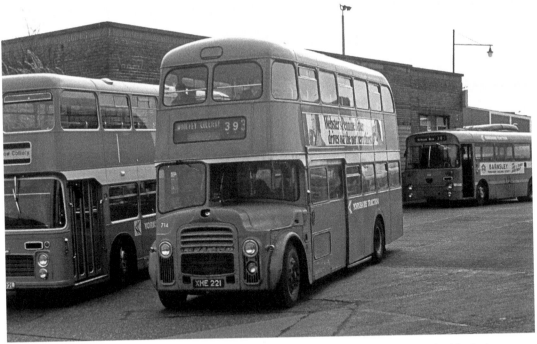

The early 1960s saw Yorkshire Traction purchase two batches of Leyland PD3A/1 double-deckers. The 1962 delivery consisted of Nos 1218 to 1229, all with Northern Counties seventy-three-seat bodywork, with a front entrance protected by a sliding door. Here we see former No. 1221 (XHE 221) in 1977, having being renumbered as 714, departing from Barnsley bus station.

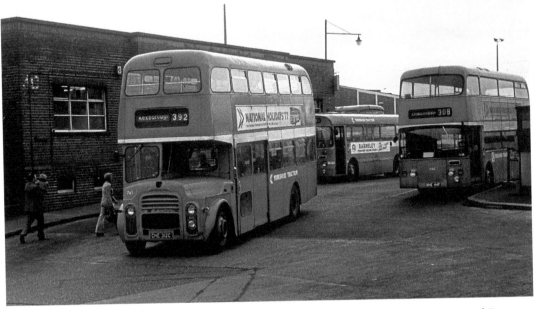

The year 1965 saw the last delivery of Leyland PD3A/1 buses, this time with more unusual Roe bodywork, but again with seventy-three seats. Having been originally numbered 1312, No. 741 (CHE 312C) is seen on the same occasion as the previous photograph.

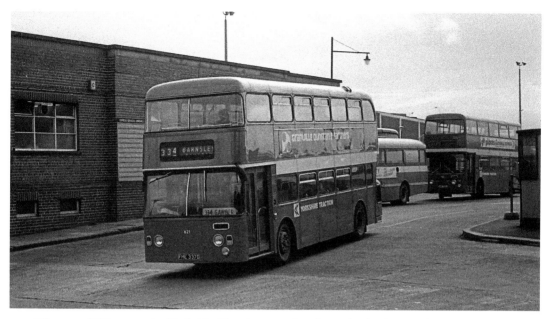

Like most BET companies, Yorkshire Traction turned to the Leyland Atlantean for its double-deck requirements. In 1965, PDR1/2 No. 1337 was received. Registered FHE 337D, it is seen here in its later guise as No. 621. Seventy-five-seat Northern Counties bodywork is fitted. The bus was photographed leaving Barnsley bus station on a local run to Gawber, in around 1977.

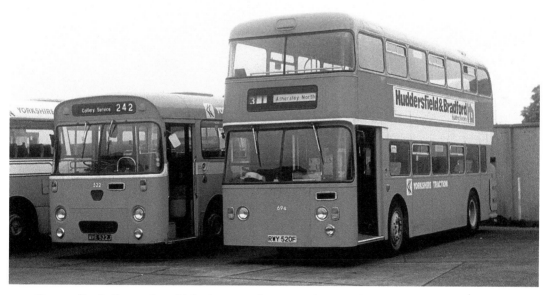

Outwardly similar to the vehicle shown in the upper photograph, Yorkshire Traction No. 694 (RWY 520F) was, in fact, a Daimler Fleetline. It had been new to Mexborough & Swinton as No. 20 and its Northern Counties body was capable of seating seventy-seven passengers. It is seen in the company of Leyland Leopard No. 522 in the parking area of Barnsley bus station in mid-1980.

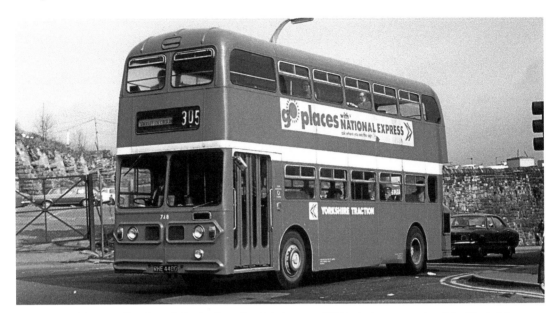

One of four Willowbrook-bodied Leyland Atlantean PDR1/1 buses received by Yorkshire Traction, but originally intended for fellow BET concern Devon General, was No. 748. It was originally delivered in Devon General colours, but with Yorkshire Traction fleet names and Barnsley registration RHE 448G. The seventy-five-seat bus is seen nearing Barnsley bus station in 1977, in NBC poppy red livery.

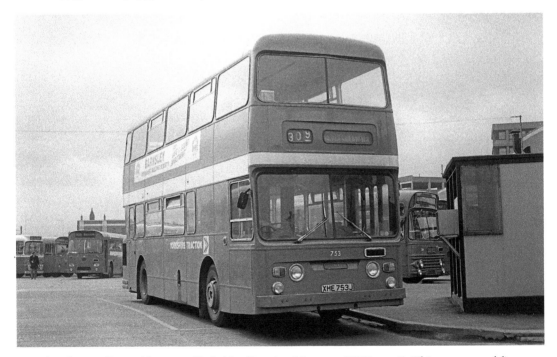

Another re-directed bus was Yorkshire Traction No. 753 (XHE 753J). This was one of five ordered by the Sheffield Joint Omnibus Committee, but was diverted to 'Tracky'. This Daimler Fleetline, seen at Barnsley bus station in around 1976, has seventy-six-seat Park Royal bodywork.

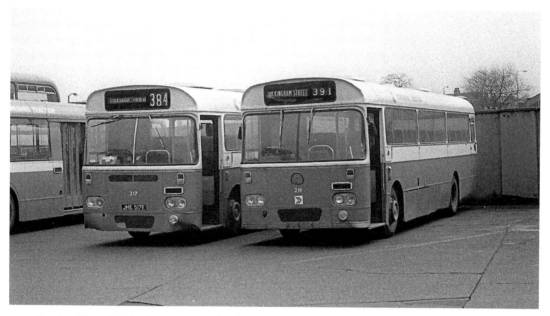

A pair of 'Tracky' dual-purpose Leyland Leopard saloons is seen at Barnsley bus station in the late 1970s. Nos 217 and 219 (JHE 517/9E) were both delivered in 1967 and have forty-nine-seat Marshall bodywork.

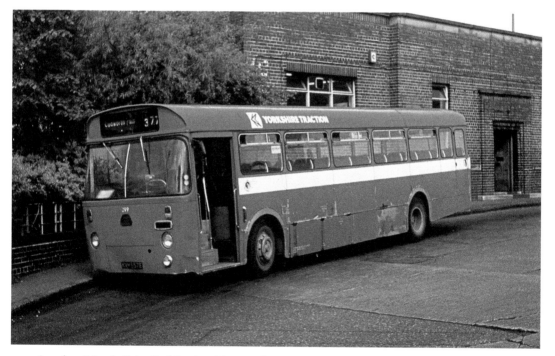

Another Marshall-bodied Leyland Leopard, No. 399 (KVH 557E), though with fifty-three bus seats, is photographed at Barnsley bus station in around 1977. This location was always a favourite place to park a bus as it was directly outside the canteen! The bus had been new to County Motors, as No. 114, in 1967.

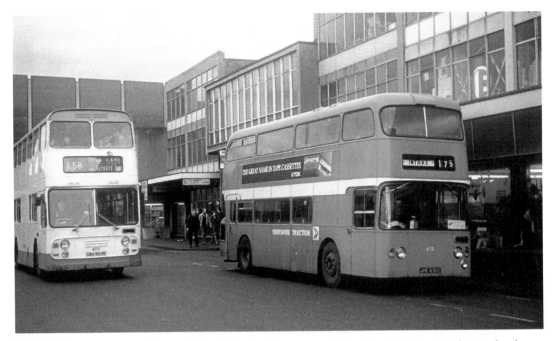

Another bus delivered to Yorkshire Traction in 1967 was No. 635 (JHE 635E). This Leyland Atlantean PDR1/2, with Northern Counties bodywork in an unusual style, was capable of carrying seventy-five seated passengers. It is seen on hire to South Yorkshire PTE, to cover a bus shortage in January 1980, in Duke Street, Doncaster.

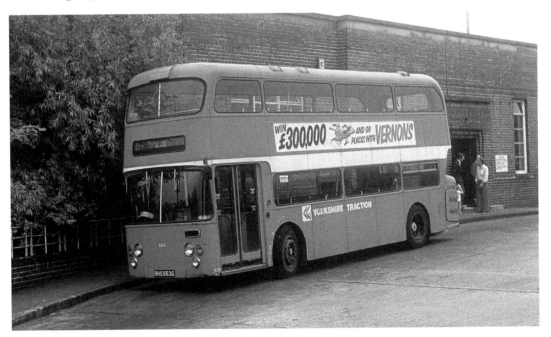

Outwardly similar to the vehicle at the top of the page, Yorkshire Traction No. 663 (RHE 663G) is a Daimler Fleetline which was built in 1969. Again, seventy-five seats are fitted inside a Northern Counties body. It is seen at Barnsley bus station in summer 1980.

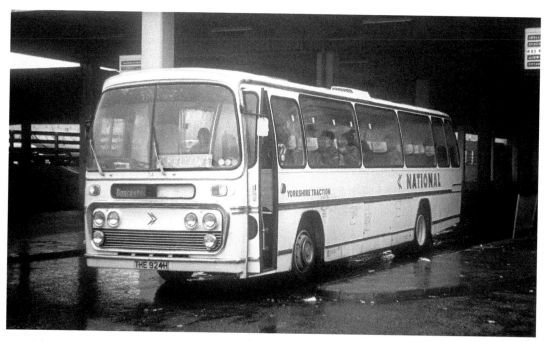

The year 1970 saw 'Tracky' upgrade its coaching fleet with a small batch of Plaxton 'Elite' forty-nine-seat coaches, all of which were on Leyland Leopard chassis. By early 1980, when this photograph was taken, they had been removed from front-line duties. No. 24 (THE 924H) is deputising for a bus and is ready to depart from Doncaster's Northern bus station on a local service to Skellow.

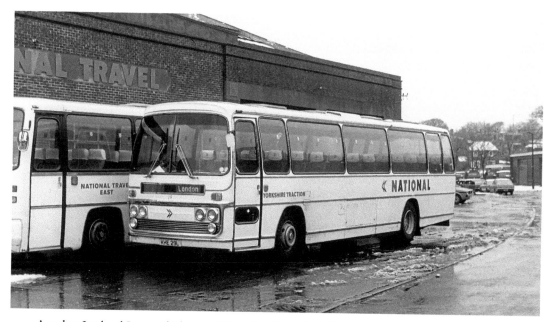

Another Leyland Leopard/Plaxton 'Elite' C49F coach, delivered in 1973, is seen on a freezing day in early 1981. No. 29 (KHE 29L) is clearly to be used on a London service, as it rests at Charlotte Road coach station in Sheffield.

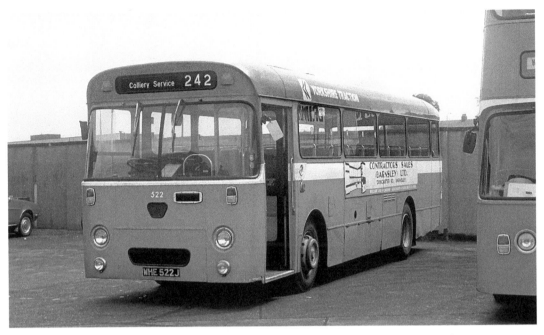

Still very much a BET-style vehicle, though delivered to 'Tracky' under NBC ownership in 1971, No. 522 (WHE 522J) is a forty-five-seat Leyland Leopard/Willowbrook combination. It was photographed resting in Barnsley bus station in mid-1980.

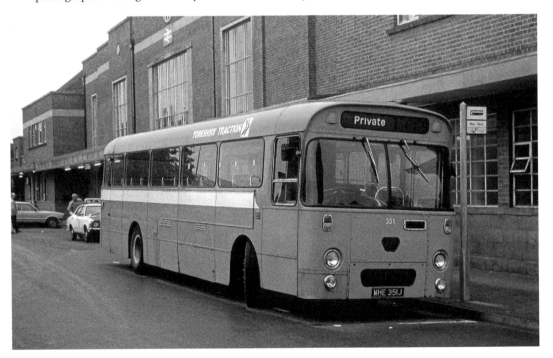

A similar bus to the one shown in the upper photograph, but longer and with fifty-three seats, No. 351 (WHE 351J) was captured on film outside Doncaster station in July 1980 while operating a rail replacement service.

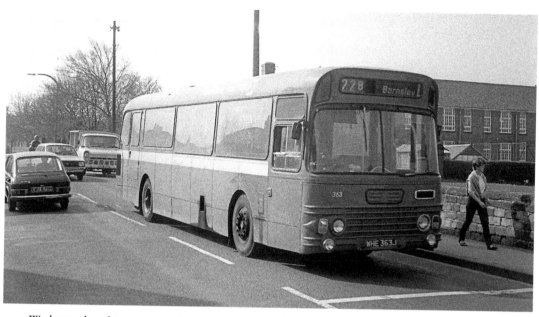

We have already seen one of the unusual Daimler Fleetline single-deckers, on page 21, in pre-NBC livery. Here is sister bus No. 363 (WHE 363J), painted in standard NBC all-over red while operating service 228 to Barnsley, in the outskirts of Wath-upon-Dearne, in around 1978.

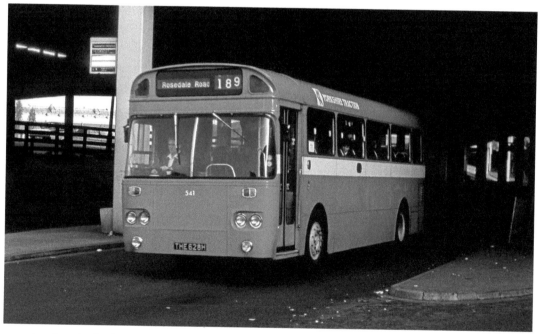

Another single-deck Daimler Fleetline in the 'Tracky' fleet was No. 541 (THE 628H). Ordered by Mexborough & Swinton, it had been delivered to Yorkshire Traction in 1970 as No. 228, intended for express services. Fitted with forty-five dual-purpose seats inside a Marshall body, it is seen on a local service leaving the Northern bus station in Doncaster in 1980. It was withdrawn the following year.

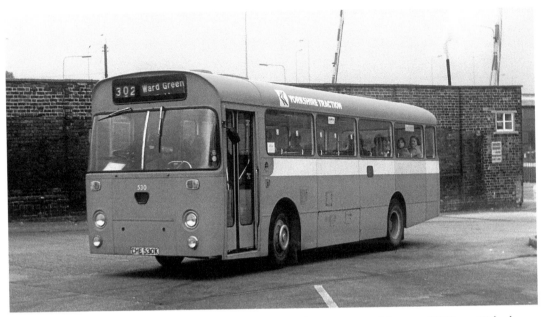

Yorkshire Traction received more Leyland Leopard saloons in 1972. No. 530 (CHE 530K) had a forty-five-seat Marshall body. It is seen arriving on its stand at Barnsley bus station in the summer of 1980.

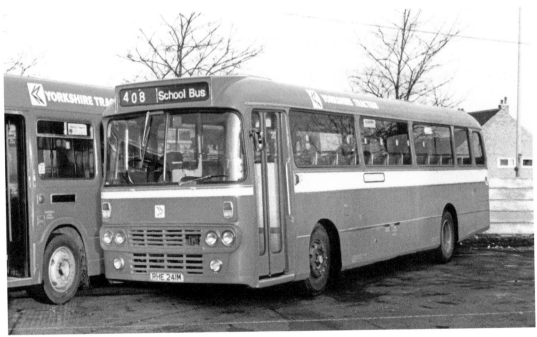

Between 1971 and 1974, 'Tracky' purchased several Leyland Leopards with forty-nine-seat dual-purpose Alexander 'Y' type bodies. No. 341 (RHE 241M) was new as No. 241, and was then renumbered to 141. It became No. 341 when it was converted to bus seating, as seen in this photograph at Wombwell depot on 5 February 1983, having been relegated to school duties. (Richard Huggins)

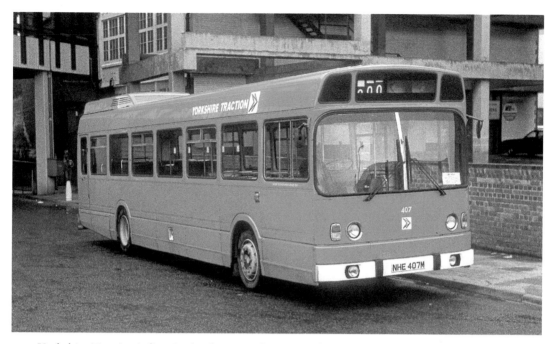

Yorkshire Traction's first Leyland Nationals appeared in 1973 and the type was to become the standard single-deck bus for NBC subsidiaries. In that year, No. 407 (NHE 407M) was delivered, seating fifty-two passengers. In 1980 it was photographed at Doncaster's North bus station, newly painted entirely in NBC red and having recently had some alterations to its front end, presumably after minor accident damage.

A later Leyland National, No. 423 (OWF 423R), is seen departing from Barnsley bus station in summer 1980, passing others of its type on the way out. At least its livery, advertising the delights of a day out by bus, breaks the monotony of a sea of red and white.

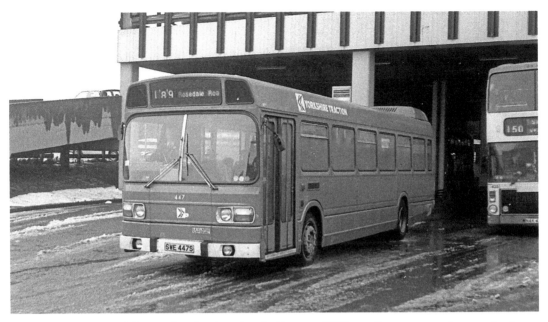

Part of the 1977 delivery of Leyland Nationals, No. 447 (SWE 447S) was yet another standard fifty-two-seat bus. It was photographed leaving the North bus station in Doncaster, emerging from the gloom below the multi-storey car park into rather inclement conditions as it heads out on a local service to Rosedale Road in around 1978.

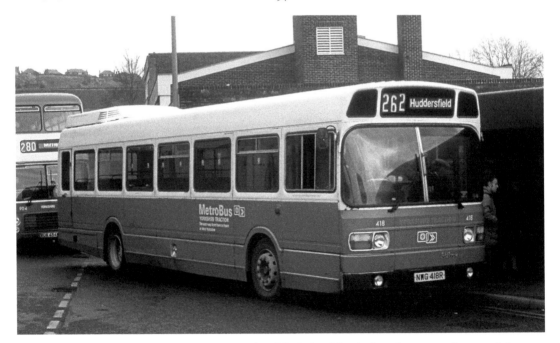

Yorkshire Traction No. 418 (NWG 418R), while being identical to the one at the top of the page, is, at least, in a different colour scheme. West Yorkshire Passenger Transport Executive requested operators to paint buses used in that territory into WYPTE's 'Metro' livery. The location is Dewsbury bus station in spring 1986.

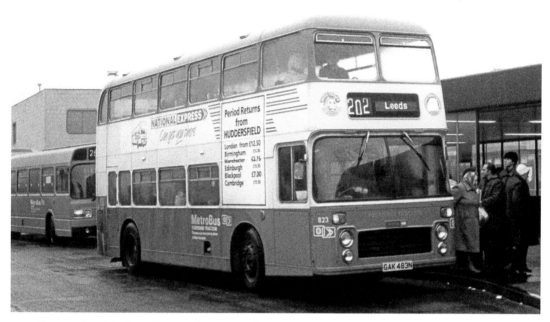

To comply with the policy of the National Bus Company, Yorkshire Traction was obliged to purchase its first ever new buses built by Bristol. Deliveries of VRTSL6G types began in 1973, with a total of thirty-three. One of these, No. 823 (GAK 483N), bodied by ECW, is seen in WYPTE livery at Dewsbury bus station on a typical February day in 1986.

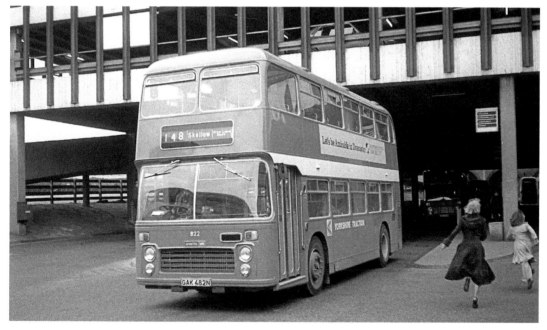

Sister to the above vehicle, No. 482 (GAK 482N), with a capacity of seventy-four seated passengers, is seen in standard NBC red livery, while departing for Skellow (Five Lane Ends) from the North bus station in Doncaster in around 1978.

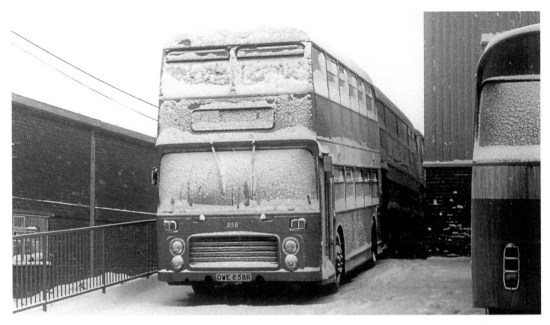

The second batch of Bristol VRs (Nos 833–864) was classified as VRT/SL3/501, having Leyland engines, including No. 858 (OWE 858R). Delivered in February 1977, again with seventy-four-seat ECW bodywork, No. 858 was stuck in the yard of Milethorne Lane depot, Doncaster (since closed), on New Year's Eve 1978 when photographed. Deep snow like this is unusual in Doncaster due to the town's sheltered position.

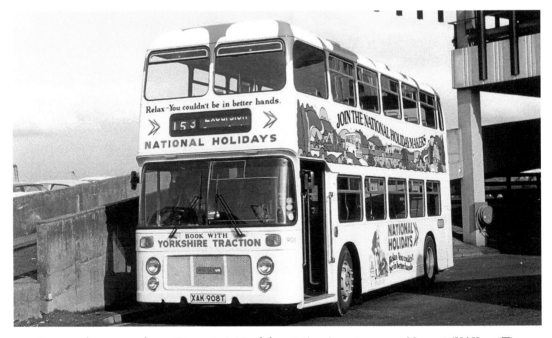

In more clement weather, at Doncaster's North bus station, in 1980, we see No. 908 (XAK 908T), which was part of the third batch of Bristol VRs received. Another VRT/SL3/501 with ECW H43/31F body, it is advertising National Holidays – which were booked through Yorkshire Traction of course!

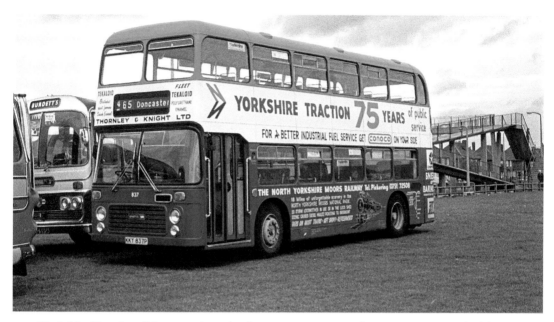

Yorkshire Traction did not need much of an excuse to paint a bus into a non-standard livery. Bristol VRT/SL3/501 No. 837 (KKY 837P), delivered in 1976, was celebrating seventy-five years of the company when photographed at Doncaster Racecourse in around 1977. (Jim Sambrooks)

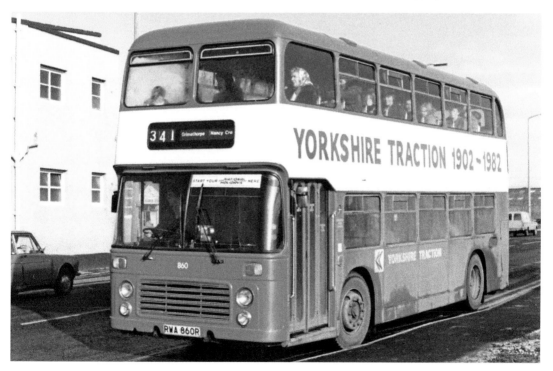

'Tracky's' eightieth birthday was commemorated by giving No. 860 (RWA 860R) a broad white band and appropriate lettering. Another Bristol VRT/SL3/501, new in 1977, it is seen on the road outside Shafton depot on 5 February 1983. (Richard Huggins)

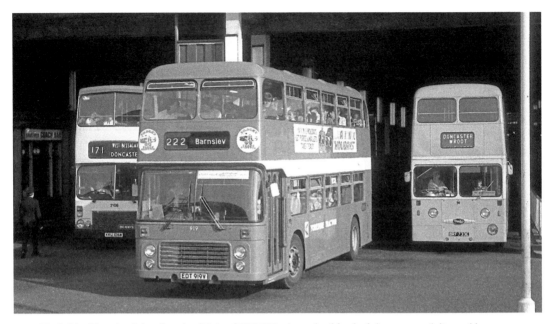

Yorkshire Traction's last batch of Bristol VRT/SL3/501 double-deck buses was delivered between 1978 and 1981, numbered 901 to 934. February 1980 saw No. 919 (EDT 919V) enter service. It is seen in as-new condition as it enters the sunshine and leaves the darkness of Doncaster's South bus station.

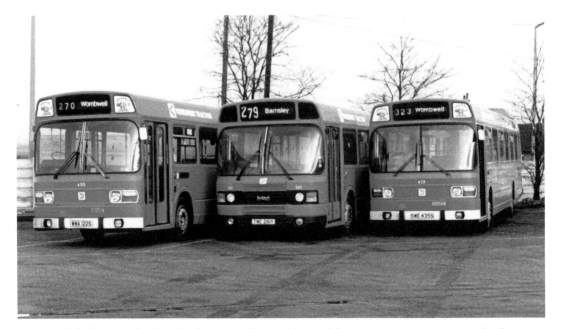

With the last standard Leyland National being delivered the previous year, 1980 saw the first batch of the later type, the Leyland National 2, being received. Typical of the breed, No. 261 (TWE 261Y), new in 1982 and a fifty-two-seat bus, is seen sandwiched between two examples of the Mark 1 versions, Nos 450 (WWA 122S) and 435 (SWE 435S). This is Wombwell depot yard, 5 February 1983. (Richard Huggins)

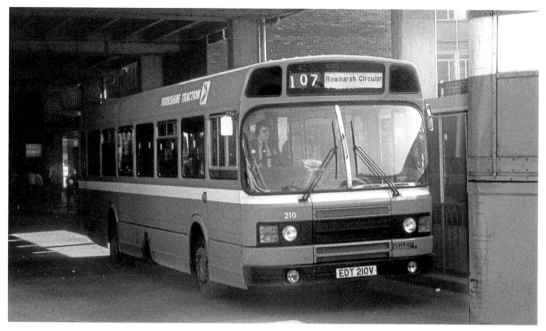

Leyland National 2 No. 210 (EDT 210V) is seen peeking out of Rotherham bus station in the spring of 1980. This fifty-two-seat bus had been new only a few months earlier, in February. The Bristol VR in front seems to be giving out a bit too much exhaust!

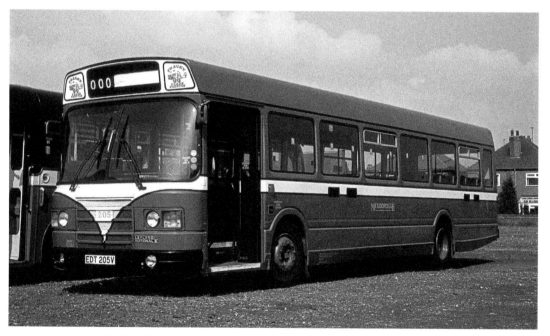

Another standard Leyland National 2 bus, No. 205 (EDT 205V) had received 'Mexborough' livery in 1982 to commemorate the old company. In July of that year it is seen on spare ground beside Doncaster fire station, waiting to depart on a rally to the Sandtoft Transport Centre, home of the trolleybus.

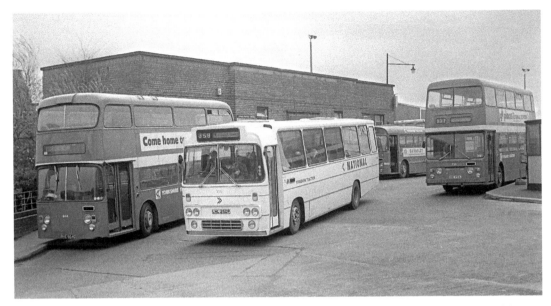

Despite the enforced influx of Leyland Nationals and Bristol VRs, Yorkshire Traction was still able to purchase Leyland Leopards for coaching duties. However, No. 250 (LHL 250P) was actually ordered by West Riding, but was delivered to Barnsley in 1976. Forty-nine-seat Alexander 'T' type bodywork is fitted, and the bus is painted in National white coach livery. The vehicle is seen leaving Barnsley bus station, in around 1977, on a local journey to Worsborough Common.

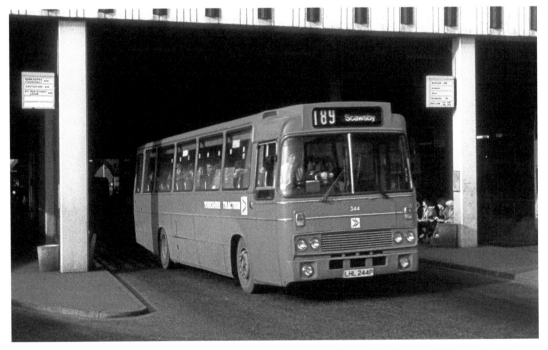

Delivered as a forty-nine-seat coach, No. 244 (LHL 244P), another Leyland Leopard/Alexander 'T', was later given bus seats and was painted into all-over red livery. Renumbered as 344, it is seen on a Doncaster local service in spring 1983 while departing from the town's North bus station.

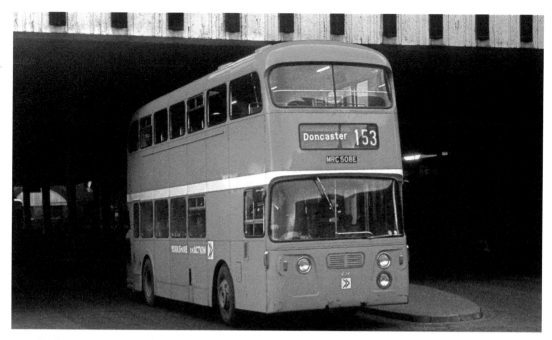

Early 1979 saw Yorkshire Traction suffer a vehicle shortage. To help alleviate matters, Trent Motor Traction No. 509 (MRC 508E) was borrowed. This Alexander-bodied Daimler Fleetline was given 'Tracky' fleet number 757 and is seen in this guise as it departs from Doncaster's North bus station in early 1979.

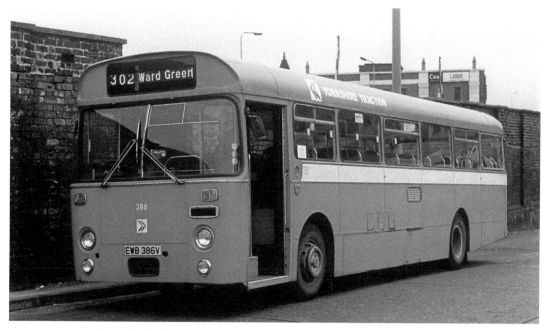

The registration of Yorkshire Traction No. 386 (EWB 386V) indicates that this bus was built in 1979 or 1980. However, it was actually a 'Tracky' rebuild of a 1965 Leyland Leopard. It was given a new fifty-three-seat Marshall body. As such, it is seen in Barnsley bus station in summer 1980.

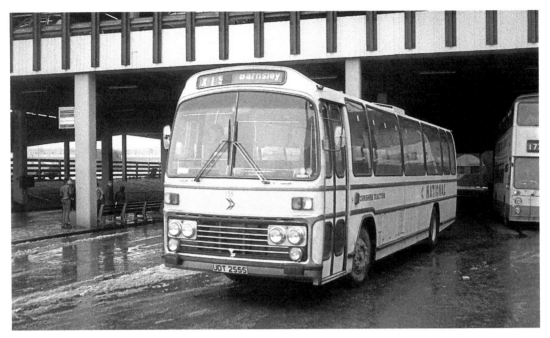

The two Leyland Leopard/Plaxton Supreme Express forty-nine-seat coaches delivered to Yorkshire Traction in 1978, UDT 255/6S, were renumbered several times. Delivered as No. 255, this example is seen as No. 155 as it leaves its Doncaster terminal for a wintry journey on the X19 fast service to Barnsley in around 1979.

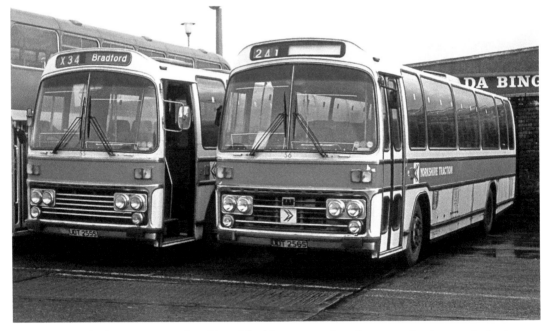

By 1982, both UDT255S and UDT256S had been renumbered to 55 and 56 respectively. As such, in an unusual version of the dual-purpose colour scheme, they are both seen parked in Barnsley bus station in 1982.

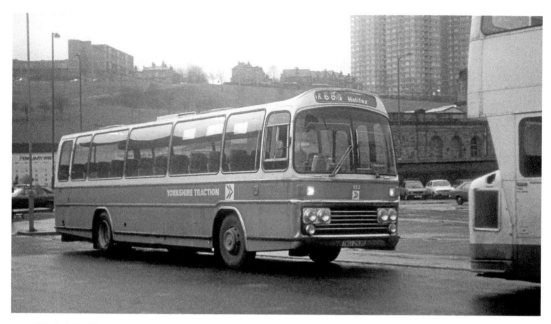

Yorkshire Traction No. 153 (TKU 253S) is outwardly another Leyland Leopard with a Plaxton Supreme Express C49F body. However, the chassis was built in 1964 and had been purchased from Yorkshire Woollen District. Painted in NBC dual-purpose livery, it is seen in Sheffield, waiting for a journey on the X66 to Halifax.

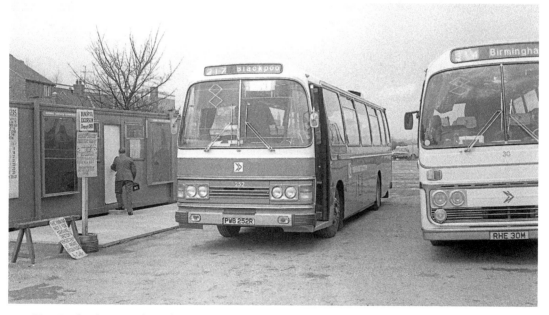

Two Leyland Leopard/Duple Dominant coaches were delivered to 'Tracky' in 1977. The second of the pair, No. 252 (PWB 252R), a forty-nine-seat vehicle, is seen in a temporary loading area beside Barnsley bus station just after delivery. It is fitted with 'grant-aid' doors and had been given dual-purpose livery, making it suitable for bus duties, though on this occasion it is about to head for Blackpool. It was later renumbered as 152.

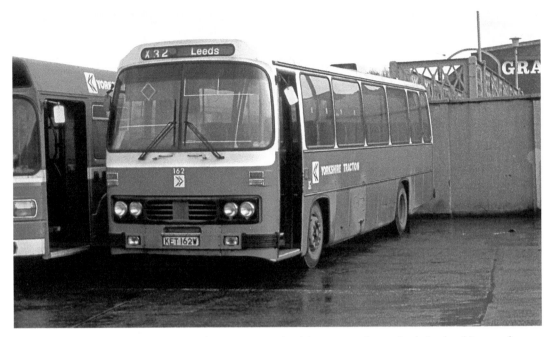

Yorkshire Traction's Nos 161 and 162 were received in 1981 and were both Leyland Leopards with forty-nine-seat Willowbrook bodies. The latter of the two, registered KET 162W, is seen in Barnsley bus station in 1982 in dual-purpose colours. Its next duty will be the X32 to Leeds.

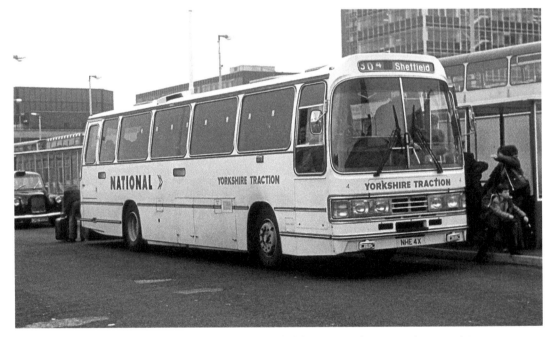

Yorkshire Traction No. 4 (NHE 4X) was intended for National Express duties and is seen on such a working, having just terminated at Sheffield's Pond Street bus station in 1982. It had been delivered in the previous year as a Leyland Leopard with forty-nine-seat Duple Dominant body, and was fitted with a single-leaf coach door.

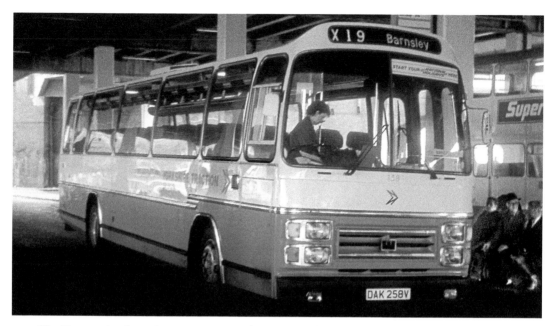

The X19 service from Doncaster to Barnsley was – and still is – a fast service between the two towns, without any deviation from the main road, via Goldthorpe. About to operate such a duty is No. 158 (DAK 258V), a 1979-built Leyland Leopard/Plaxton Supreme Express C49F. It is seen in the dark depths of the North bus station in Doncaster, underneath a multi-storey car park, in 1982.

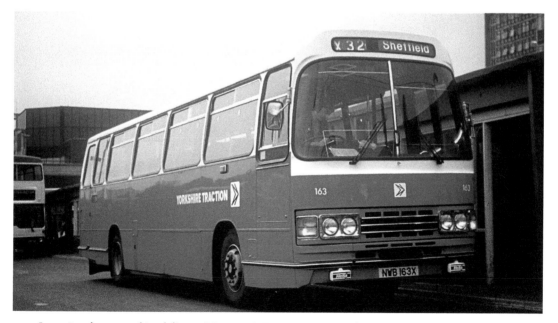

In 1981, the year of its delivery, No. 163 (NWB 163X) was photographed at Pond Street bus station in Sheffield, having just arrived on the X32 from West Yorkshire. Painted in NBC dual-purpose livery, it is one of two Leyland Leopard/Duple Dominant forty-nine-seat coaches with folding 'grant-aid' doors.

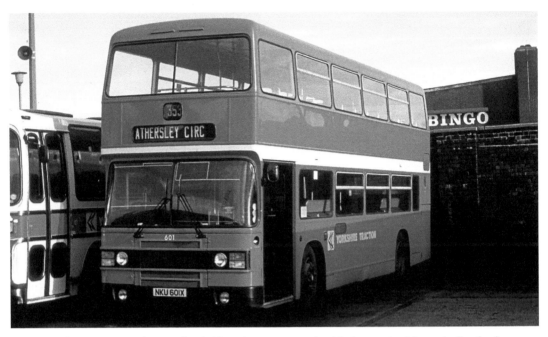

Yorkshire Traction's first Leyland Olympians were received in late 1981. Numerically, the first was No. 601 (NKU 601X). Fitted with a seventy-seven-seat ECW body, it is seen just after a shower in Barnsley bus station in 1982.

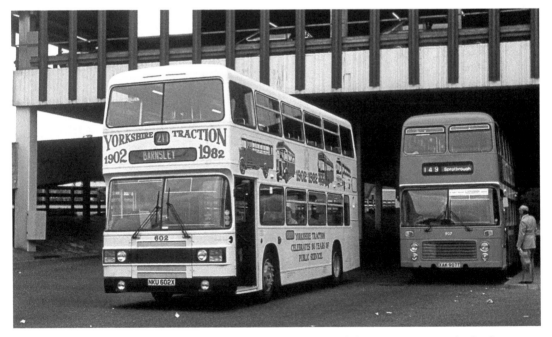

'Tracky's' second Leyland Olympian, No. 602 (NKU 602X), did not appear in standard colours but was given this special livery to help celebrate eighty years of the company's existence. It is seen leaving the North bus station in Doncaster on a 211 service to Barnsley via South Elmsall in 1982.

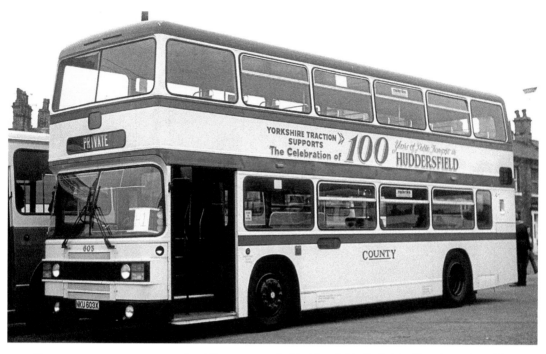

To commemorate 100 years of public transport in Huddersfield, Yorkshire Traction painted its third Leyland Olympian/ECW bus into the old County Motors livery. No. 603 (NKU 603X) was photographed in those colours at a bus rally in Huddersfield in mid-1983.

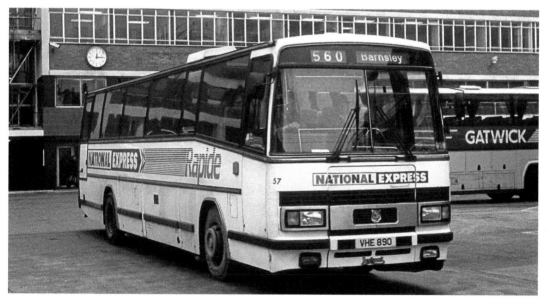

Yorkshire Traction's management loved to re-register their coaches, giving them traditional Barnsley registrations ('HE') or ones containing 'YTC', while also, of course, disguising their true age. Coach No. 57 (VHE 890), a Leyland Tiger/Plaxton Paramount C50F, was originally new as A57 WDT in 1983. Having been given its new identity, it was photographed at London's Victoria coach station in 1986.

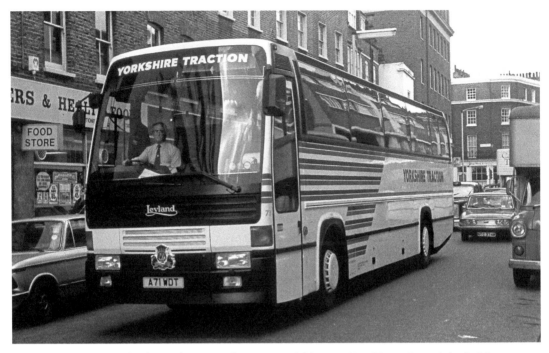

Here is a rare Leyland Royal Tiger with an unusual fifty-seat Roe 'Doyen' coach body, No. 71 (A71 YDT). It was captured on film close to Victoria coach station in London in autumn 1983. This coach was later re-registered as OHE 50.

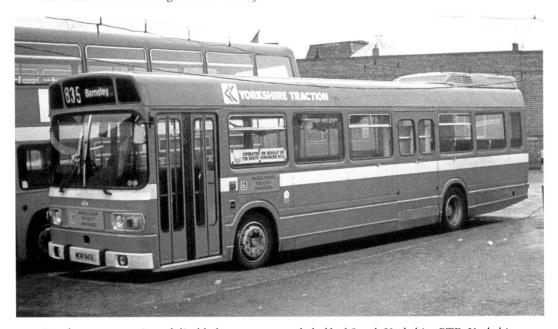

For the transportation of disabled passengers on behalf of South Yorkshire PTE, Yorkshire Traction purchased a former Northern General dual-doored Leyland National, No. 484 (MCN 845L). The centre exit was converted into a wheelchair lift and in such condition it is seen at Barnsley bus station in January 1984.

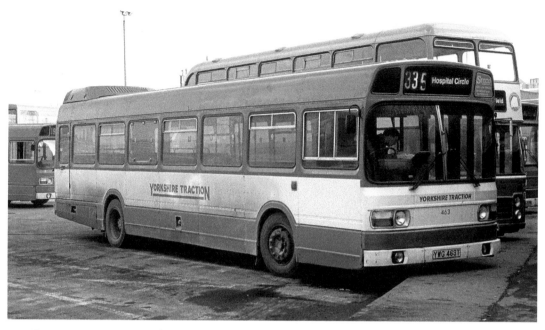

By 1986, in preparation for privatisation, variations of the standard red and white NBC colour schemes were being introduced. Even the old-style fleet name re-appeared, as seen on 1979-built Leyland National No. 463 (YWG 463T), which stands in Barnsley bus station in March 1986, showing no signs of NBC ownership.

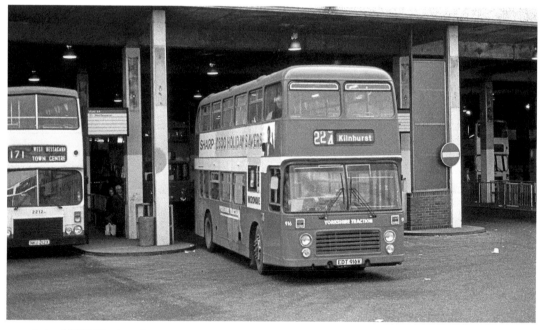

Bristol VRT/SL3/501 bus No. 916 (EDT 916V), with seventy-four-seat ECW bodywork, is seen leaving the South bus station in Doncaster on a 224 service to Kilnhurst in early 1986. Again, the bus now shows no indication that it belongs to the National Bus Company.

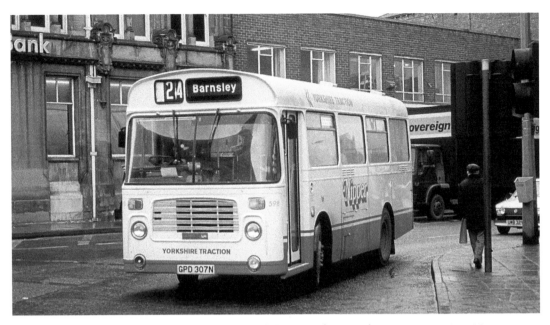

Acquired by Yorkshire Traction via South Yorkshire PTE for Barnsley 'Nipper' services, No. 598 (GPD 307N) had been new to London Country as fleet number BN39 and was a Bristol LHS6L/ ECW thirty-five-seat bus. It is seen in central Barnsley in 1986. No. 598 was one of two, both of which were sold in 1988, for further service with Lincolnshire Road Car Company.

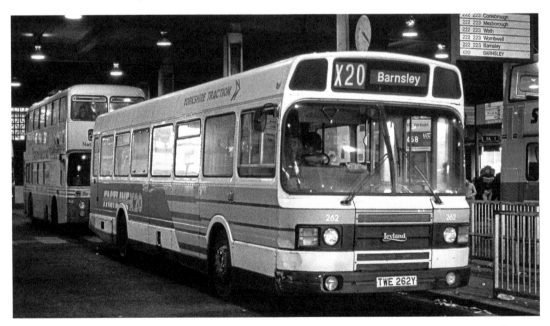

The 222/3 group of services from Doncaster to Barnsley took a long time to travel between the two towns along the Dearne Valley, serving various housing estates as well as the substantial former mining communities along the way. Therefore, the X20 direct service, sticking to the main road, was introduced. In a dedicated livery for such duties is Leyland National 2 No. 262 (TWE 262Y), which is seen inside the South bus station, Doncaster, in March 1986.

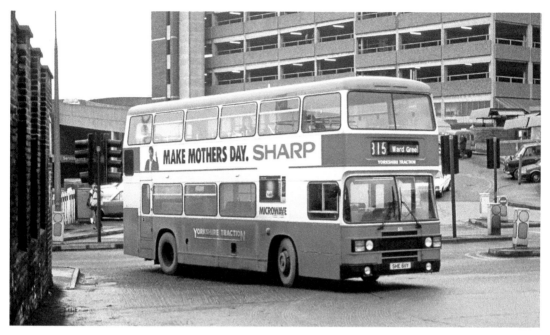

In an even more radical move away from NBC livery, No. 611 (SHE 611Y), a 1982-built Leyland Olympian/ECW seventy-seven-seat bus, was painted into traditional 'Tracky' colours. It certainly brightens up a dull Barnsley day as it enters the bus station in spring 1986.

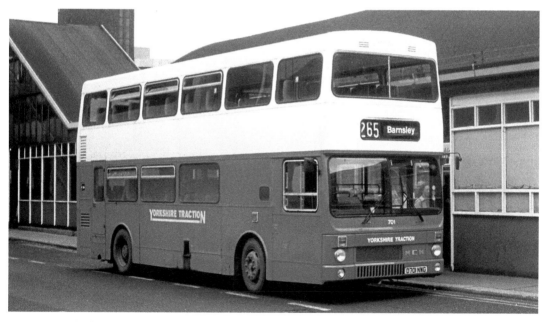

One of the last buses to be delivered to Yorkshire Traction as a National Bus Company subsidiary was No. 701 (D701 NWG), a Mark II MCW Metrobus dual-purpose double-decker, seating seventy-two passengers. It is seen at Sheffield bus station in September 1986. Only four of the batch were to this layout, with the other twelve of the batch having bus seats. Yorkshire Traction was sold to its management on 1 January 1987.

More Takeovers

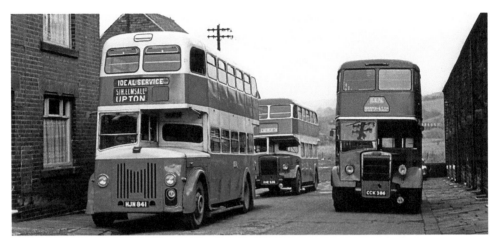

1974 saw Wray's, trading as Ideal Service, sell its operations to Yorkshire Traction, including a Barnsley to Pontefract route and some short workings. No vehicles were retained from the – by then – rather antiquated bus fleet. Back in 1967, Les Flint visited the depot at Hoyle Mill on 7 May and found HJN 841, an ex-Southend Leyland PD2/20 with Massey bodywork, with former Ribble CCK 386, an all-Leyland PD2/2, alongside. To the rear can be seen KHE 526, a rebuilt Leyland PS1 with Roe bodywork, which had come from Yorkshire Traction. The other half of the Ideal operation, Taylor's, had sold out to 'Tracky' in 1967.

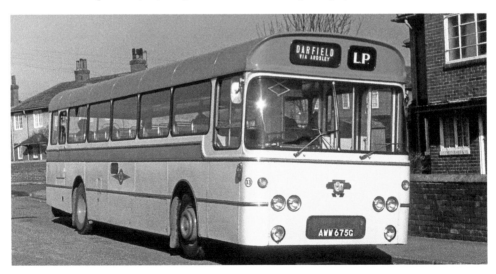

Most of the barnsley area independents had vanished by the 1970s, , leaving just Larratt Pepper's regular Barnsley–Thurnscoe service. This too was purchased by Yorkshire Traction, in 1978. Again, no vehicles were involved and Larratt Pepper continued to operate as a coach business. A regular performer on the stage service was AWW 675G, a Plaxton-bodied Leyland Leopard fifty-five-seat bus. It is seen beside the depot, in Thurnscoe, in 1978.

Into Private Hands

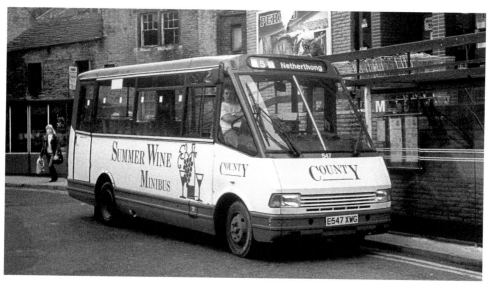

One of the first actions of the newly privatised Yorkshire Traction Company was to reintroduce the liveries of a couple of vanished operators. The blue and cream colours of County Motors reappeared around the Huddersfield area. In a dedicated version of County Motors' identity is No. 547 (E547 XWG), a twenty-three-seat MCW Metrorider, seen in *Last of the Summer Wine* territory, at Holmfirth bus station in January 1989.

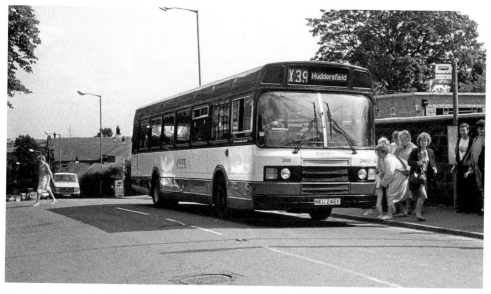

Formerly a standard Yorkshire Traction Leyland National 2 saloon, No. 246 (NKU 246X) is seen in County Motors' livery while loading up in Penistone in summer 1987.

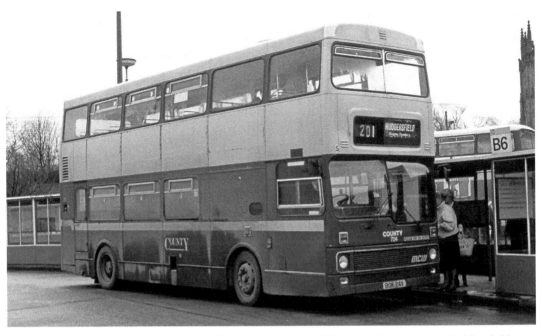

This MCW Metrobus, No. 724 (BOK 24V), was a second-hand purchase for the Huddersfield fleet. It is seen in the Central bus station in Leeds in 1991, still mostly in the livery of its previous operator, West Midlands Transport, to whom it was new in 1980.

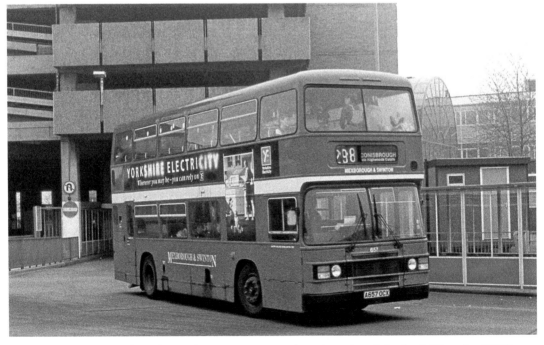

The green livery of Mexborough & Swinton was also reintroduced. Leyland Olympian/ECW seventy-seven-seat bus No. 657 (A657 OCX) is seen in this guise, leaving Rotherham bus station on a journey through former M&S territory to Conisbrough in April 1990.

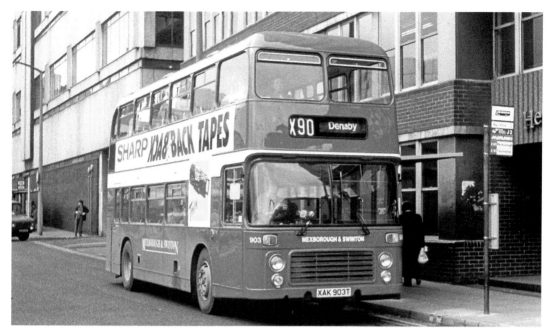

Sheffield was never served by Mexborough & Swinton, so green-liveried Bristol VRT/SL3/501 with ECW bodywork No. 903 (XAK 903T) makes an unusual sight as it awaits departure time in the street alongside Pond Street bus station, on the X90 to Denaby, in 1987.

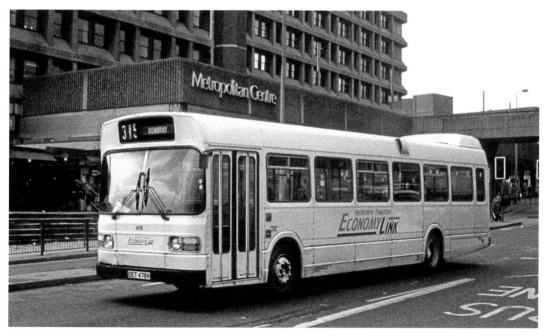

To combat fierce competition in Barnsley, Yorkshire Traction introduced 'Economy Link' services into the town. On such duties in summer 1991 is No. 478 (DET 478V), a 1979-built, fifty-two-seat Leyland National. It is seen approaching Jumble Lane level crossing while passing the ugly Metropolitan Centre, which will soon be rebuilt.

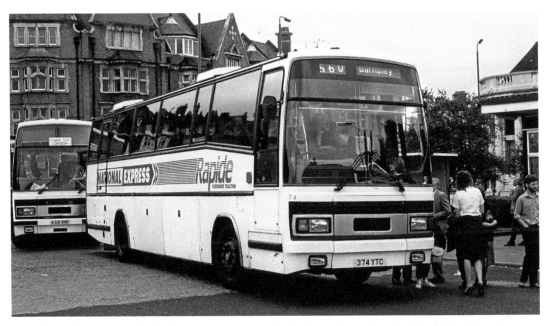

The taller version of the Plaxton Paramount body is seen here, fitted to Yorkshire Traction
No. 74. Registered 374 YTC, it had been new in 1984 as A74 YDT. Unusually, it is a Leyland
Royal Tiger, with a forty-six-seat capacity, plus toilet. It is seen at Golders Green bus station
in North London, only a few miles into its long journey from Victoria to Barnsley. The year is
1987, so it is after privatisation, but the coach is still in standard NBC coach livery.

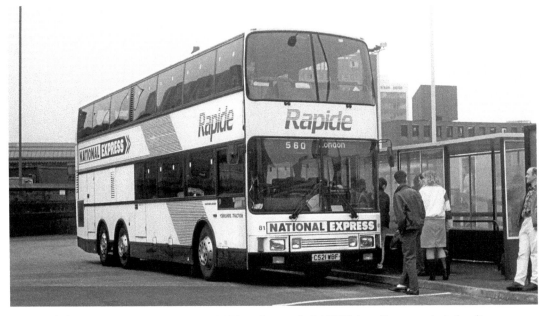

Yorkshire Traction No. 81 (C521 WBF), a three-axle MCW Metroliner coach, is loading up
in a temporary section of Sheffield's bus station in mid-1988. The vehicle had been new as a
seventy-one-seater, with two doors and a toilet, to Midland Red North, with whom it had been
the only one of its type. This coach later passed to Ambassador Travel, in Norfolk.

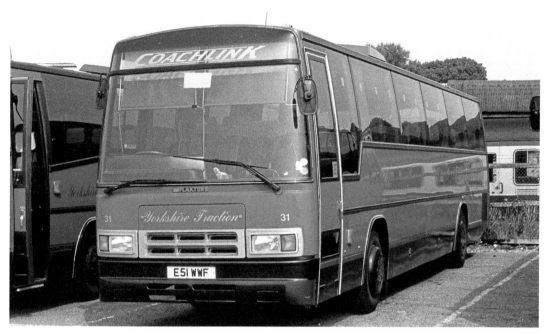

The late 1980s and early 1990s saw Yorkshire Traction paint much of the coach fleet into a smart red livery, as seen having been applied to No. 31 (E51 WWF). Two years old when photographed in Bridlington in summer 1989, it is a Scania K92CRB with Plaxton fifty-five-seat coachwork. Scania supplied a good number of buses to 'Tracky' during the privatisation era.

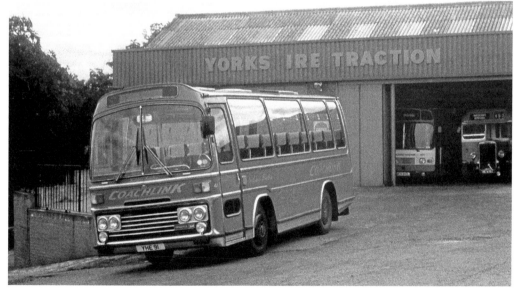

A much more unusual vehicle to carry the red coach livery was No. 41 (YHE 91). This Bristol LHS6L/Plaxton coach had been new to W. Gash & Sons of Newark as No. BR4 (WNN 572S). The Gash business had been taken over by Lincolnshire Road Car, which, in turn, had passed into the Yorkshire Traction Group. It is seen at Barnsley depot in September 1989. No. 41 later returned to Lincolnshire. (Jim Sambrooks)

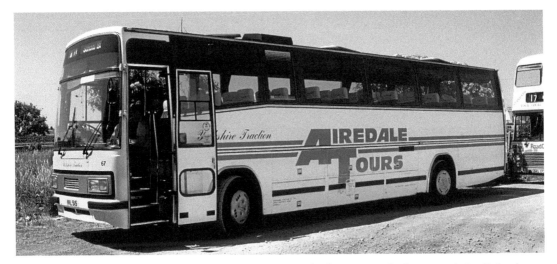

The registration WVL 515 had originally been applied to a Lincolnshire Road Car Bristol RELH6G/ECW coach, which had later become a mobile office. Leyland Tiger/Plaxton Paramount coach B57 DKW was new to Lincolnshire Road Car as No. 1417, though it had been intended for East Midland. By the time it had been transferred to Yorkshire Traction and photographed in Skegness, it had been re-registered to become WVL 515 (fleet number 67). Allocated to 'Airedale Tours' duties, it is seen in summer 1989.

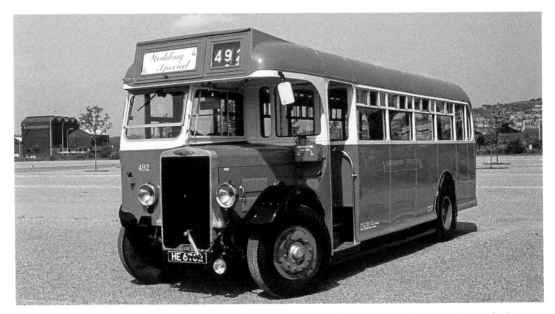

Yorkshire Traction No. 492 (HE 6762), a Leyland Tiger TS7 of 1935, originally carried a Roe body. It was rebodied in 1950 by Weymann and ran in service until 1958. It was sold for further service to a building contractor and then moved on to a travelling showman before becoming a static caravan. It was, much later, repurchased by Yorkshire Traction and superbly restored as a special events and private hire vehicle – often being used for weddings, as shown by the indicator blind. However, on this occasion, in July 1994, it is on a private hire duty, visiting various hostelries in South Yorkshire. Here it is seen in the car park next to the Enfield Arms near Attercliffe, Sheffield.

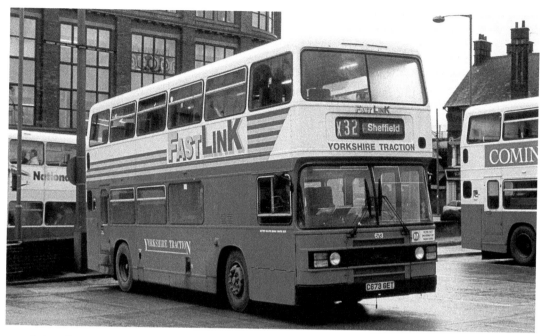

It is a damp summer's day in 1991 and Yorkshire Traction No. 673 (C673 GET) has reached Leeds bus station on the X32 'Fastlink' service. In a dedicated livery for such duties, this Leyland Olympian/ECW bus has been fitted with dual-purpose seating. It had been new to the company in 1985.

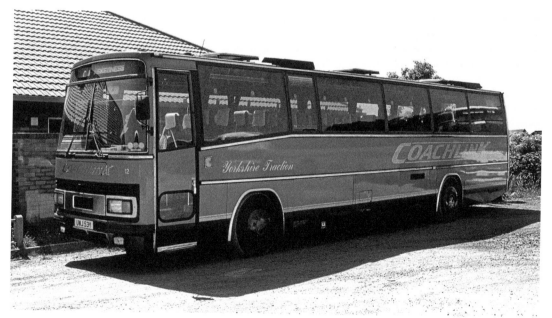

Plaxton Paramount-bodied Leyland Tiger UWJ 53 Y had been delivered to Yorkshire Traction as No. 53 in 1983. After a spell with Lincolnshire Road Car, it had been re-registered, then given back its original registration upon return to 'Tracky' – though it then gained fleet number 12. As such, it is seen back in Road Car territory at Skegness in summer 1989.

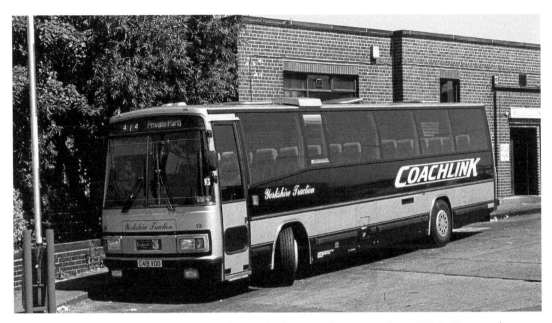

Another transfer from the associated Lincolnshire Road Car was C419 VDO. New to that company as No. 1419 in 1986, this Leyland Tiger/Plaxton Paramount coach still retained its Road Car 'Coachlink' colours when seen as 'Tracky' No. 19 in Barnsley bus station in summer 1989.

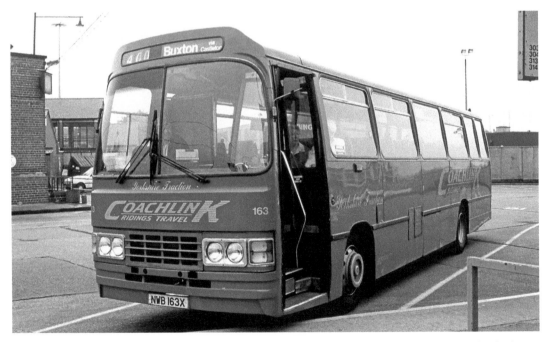

Yorkshire Traction No. 163 (NWB 163X) was delivered new as a Duple Dominant-bodied Leyland Leopard in 1981, intended for use as a dual-purpose vehicle for longer distance purposes. Upon privatisation it received 'Fastlink' livery, but by 1994, when photographed in Barnsley bus station, it had been painted into the all-over red coach colour scheme. It is seen about to depart on a service over the Pennines to Buxton via Castleton.

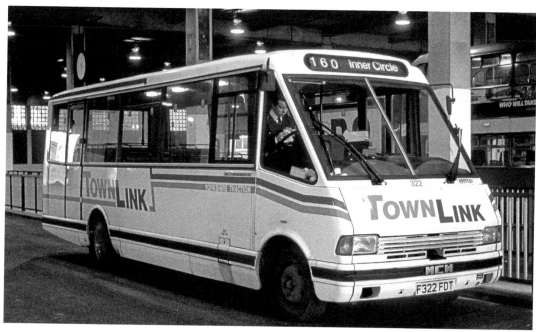

Like most of Britain's bus operators, Yorkshire Traction invested heavily in minibuses around the end of the 1980s. New in 1989 was No. 322 (F322 FDT), a thirty-three-seat MCW Metrorider, which is seen inside Doncaster's North bus station when less than a month old in March 1989. It is wearing the 'Townlink' livery normally used on such services.

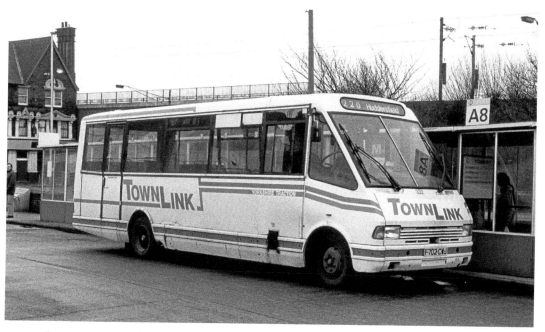

A shorter version of the MCW Metrorider, seating just twenty-three passengers, is seen in Leeds bus station in early 1992, again having been given 'Townlink' lettering. No. 332 (F702 CWJ) had been new to Sheffield operator SUT in 1988.

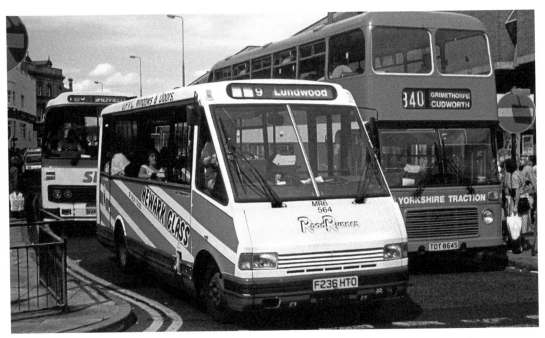

Another twenty-three-seat MCW Metrorider, No. 564 (F236 HTO), is seen in Barnsley town centre in September 1989. It had just been transferred from Road Car, who had inherited it when they took over Newark independent W. Gash & Sons. 'Tracky' had pressed it into service still displaying its Gash number, MR6, and a large advert for Newark Glass.

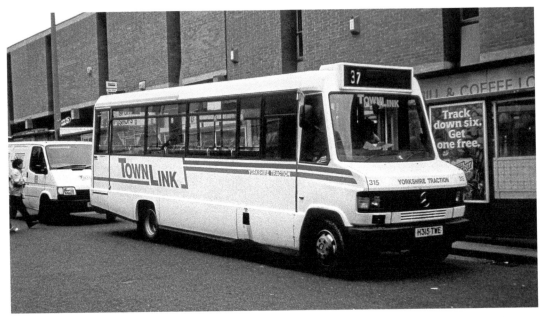

Yorkshire Traction also purchased a batch of Mercedes-Benz 811D minibuses for 'Townlink' services. Allocated to such duties in spring 1991 was No. 315 (H315 TWE), which was photographed in Midland Street, Barnsley, and featuring its thirty-one-seat Carlyle bodywork. It should also be mentioned that 'Tracky' also purchased several Renault S75 minibuses from London Buses.

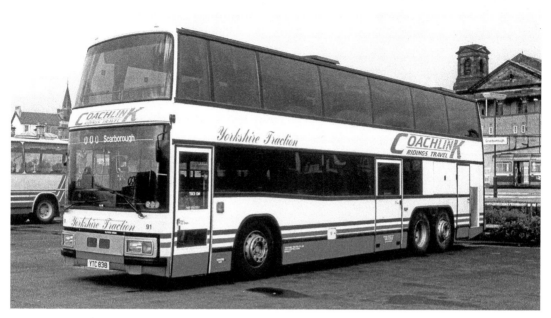

An unusual coach to enter the 'Tracky' fleet in 1986 was No. 91. Originally registered C91 KET, it was a Plaxton 4000 double-decker, built on a Neoplan underframe and powered by a Gardner engine. Intended for National Express duties, by 1995 it had been painted into 'Coachlink' livery and re-registered as YTC 838 when photographed on a coastal outing in Scarborough.

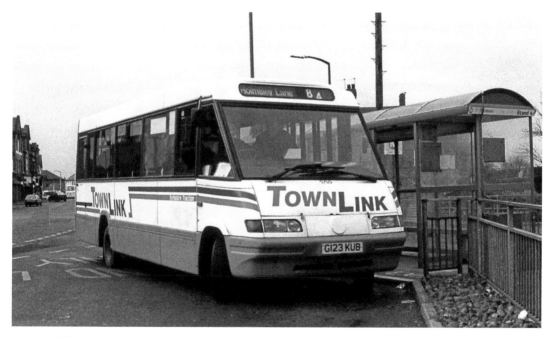

Yorkshire Traction purchased several Mercedes-Benz 811D/Optare StarRider saloons new, but this one had been originally a demonstrator. No. 309 (G123 KUB), built as a twenty-seven-seater, is seen in the small bus station in the West Yorkshire town of South Elmsall in 1999.

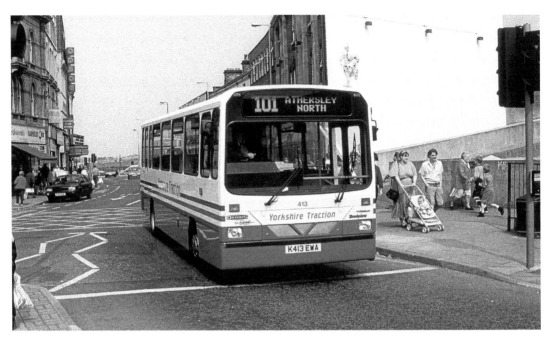

Various smaller buses were bought by Yorkshire Traction for local duties. This Dennis Dart was one of them, with a Wright 'Handybus' body seating forty-one passengers. No. 413 (K413 EWA) is seen in Barnsley town centre, heading for Athersley, in spring 1993.

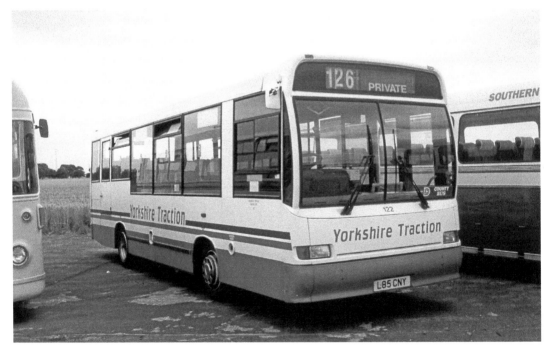

The Volvo B6-50 also featured in the 'Tracky' fleet. No. 122 (L85 CNY), with thirty-two-seat, dual-purpose Marshall bodywork, had been new to South Wales operator Bebb of Llantwit Fadre. It was photographed at the Sandtoft Gathering in July 1999.

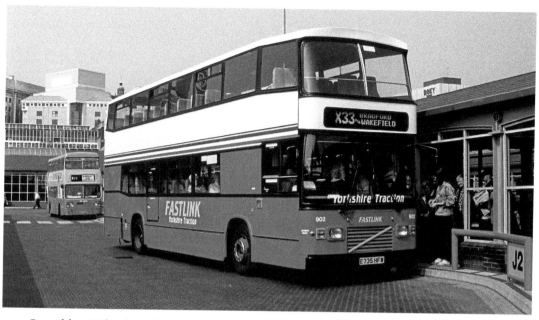

One of four Volvo B10M-50/East Lancs double-deck coaches new to Lincoln City Transport in 1988, Yorkshire Traction No. 902 (E735 HFW) is seen at Sheffield Interchange in May 1993. It was intended by 'Tracky' for 'Fastlink' services, which it was operating in this case – the X33 to Bradford. It was originally registered KIB 6527. Lincoln City Transport had been purchased earlier in 1993 by the Yorkshire Traction Group and absorbed into the Road Car fleet.

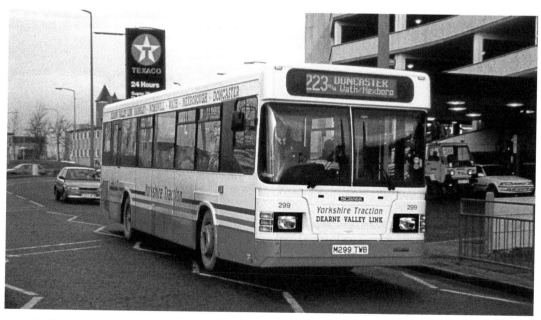

Yorkshire Traction continued to buy Scanias for its single-deck requirements. No. 299 (M299 TWB) was one of five L113CRL types with East Lancs 'European' bodywork that were received in 1995. This fifty-three-seat bus is seen approaching its Doncaster terminus on the 223 service from the Dearne Valley just after delivery.

One of only two Spartan saloons in the 'Tracky' fleet with East Lancs 'Opus 2' fifty-three-seat bodies, No. 201 (N201 CKU) was photographed alongside Barnsley railway station in mid-1996. This one and its sister, No. 202, went to Wigan Bus Company for further service.

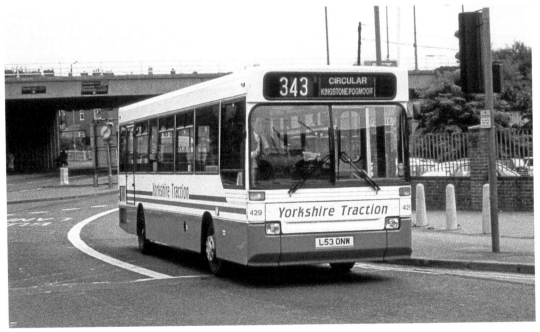

The year 1994 saw large independent South Yorkshire Road Transport of Pontefract being sold to West Riding. Three Dennis Dart/Plaxton B39F saloons had just been purchased by that company and were passed to the large Wakefield concern, but were soon sold to Yorkshire Traction as non-standard. No. 429 (L53 ONW) is seen approaching Barnsley bus station in October 1994.

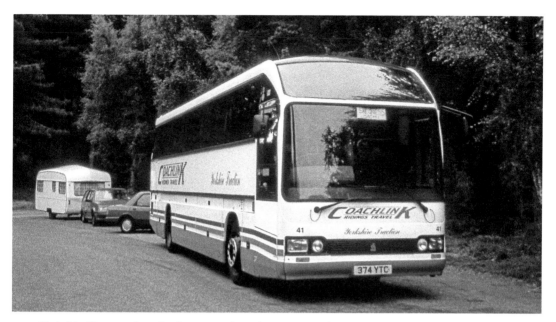

Yorkshire Traction bought this unusual Duple 425 integral coach as a one-off for Ridings Travel duties. Originally registered J241 BWE, it is seen as No. 41 (374 YTC) in a lay-by near Market Rasen, resting from a Skegness duty, in August 1999. (Jim Sambrooks)

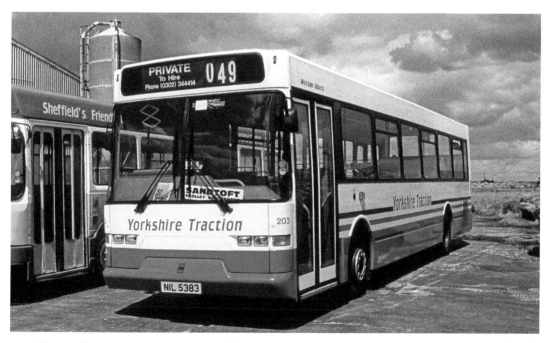

Yet another Scania/East Lancs combination, No. 203 (NIL 5383) is seen on display at the Sandtoft Gathering in July 1997, only a month after being delivered to 'Tracky' from a rebodying in Blackburn as a fifty-three-seat bus. New as D92 ALX with British Airways, as a Scania K112CRB with an earlier East Lancs body it had passed to Yorkshire Terrier, and can be seen in its original condition on page 87.

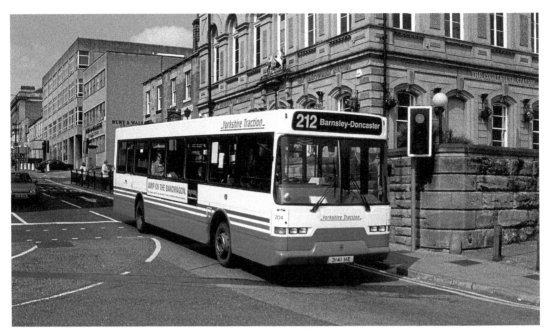

Another rebodied Scania K112CRB, formerly registered D85 ALX, is No. 204 (3141 HE), which is seen approaching Barnsley bus station on a sunny March day in 2001.

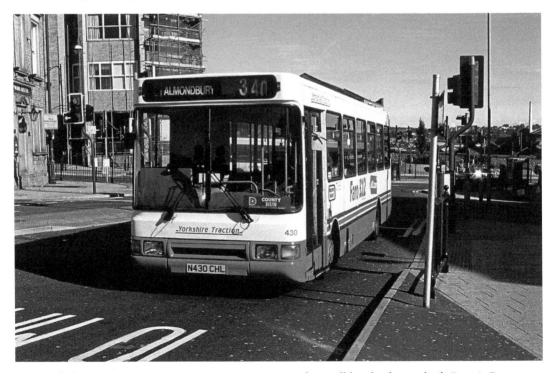

Yorkshire Traction No. 430 (N430 CHL) was part of a small batch of 1995-built Dennis Darts with Northern Counties thirty-nine-seat bodies. It was photographed arriving in Huddersfield bus station in 2005.

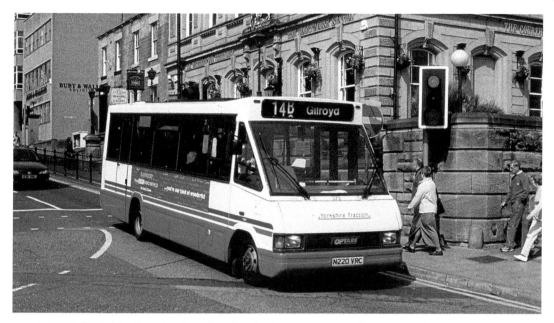

Though Yorkshire Traction bought a batch of MCW Metroriders new, it also got some from other sources. The company purchased a good number of further Metroriders – thirty-one-seat Optare versions from Trent Motor Traction. No. 372 (N220 VRC) is seen in Barnsley, passing the old Court House, and about to enter the bus station in 2001.

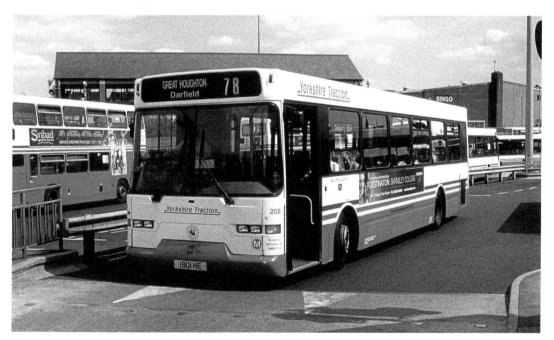

Yorkshire Traction No. 208 (1901 HE) was a unique bus in the fleet. This Kirn Mogul with East Lancs 'Flyte' forty-nine-seat bodywork was new in 2001. It is seen departing from Barnsley bus station in August 2003. The bus passed to Stagecoach in 2005 and the registration was later transferred to another bus.

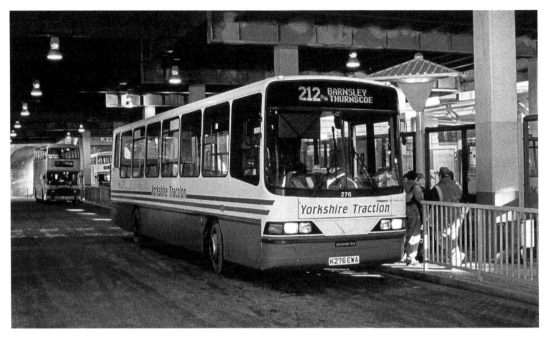

One of five Scania K93CRB saloons with Wright 'Endurance' fifty-one-seat bodies, No. 276 (K276 EWA) was found in Doncaster's South bus station in early 1993, having been new in 1992. It is will soon load up for the long journey to Barnsley via Thurnscoe on route 212. The batch was later transferred to Huddersfield depot.

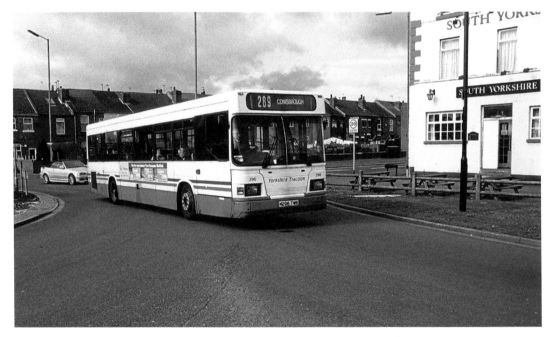

Yorkshire Traction No. 296 (M296 TWB), another Scania L113CRL with East Lancs 'European' fifty-three-seat bodywork, is seen in Mexborough, passing the South Yorkshire pub, in October 2005. The bus is heading for Conisbrough on service 289.

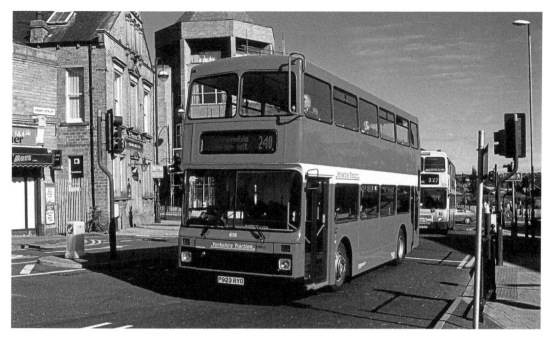

It was not unusual for the privatised Yorkshire Traction Company to buy second-hand buses. Looking rather smart in all-over red is No. 616 (P923 RYO), a Volvo Olympian/Northern Counties double-decker, which is seen in Huddersfield in 2005. It had been new to London General as fleet number NV123 and had been converted to single-door prior to entry into 'Tracky' service.

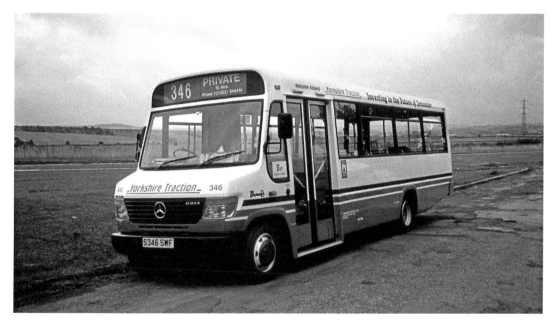

Mercedes O814D/Plaxton thirty-one-seat minibus No. 346 (S346 SWF) was photographed by its driver, Jim Sambrooks, while taking a break in a lay-by near Goldthorpe in autumn 1998 when almost new (as part of a small batch). No. 346 was later transferred to the Strathtay operation in Scotland.

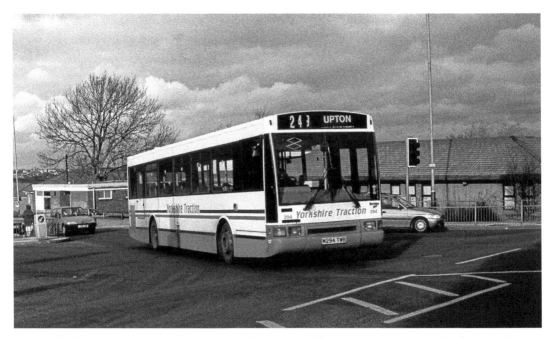

Yorkshire Traction No. 294 (M294 TWB) was one of five Northern Counties-bodied Scania L113CRL types delivered in 1994. This fifty-two-seat bus was photographed in Pontefract when setting out on a journey to Upton in 1999.

To add to the variety of chassis types that Yorkshire Traction ordered, 2001 saw the company add five DAF DE02 buses to the fleet. Bodied by East Lancs with forty-six-seats, No. 212 (X212 HHE) was photographed in Barnsley just after delivery.

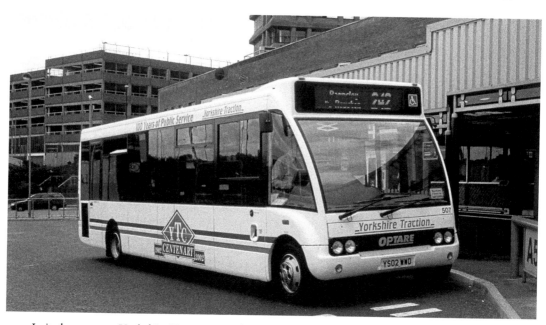

In its later years, Yorkshire Traction purchased a good number of Yorkshire-built Optare Solos for local routes. Seen on such a duty, in Barnsley bus station in the summer of 2002 is No. 507 (YS02 WWD). This thirty-three-seat bus has been given additional markings to help celebrate 100 years of the company's existence.

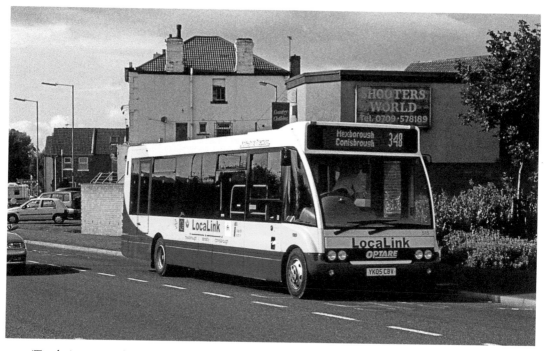

'Tracky' continued to receive Optare Solos right into 2005. New in that year, and seen in October, was No. 515 (YK05 CBV), which has been painted into a South Yorkshire PTE-inspired livery for tendered bus duties. The bus is approaching Mexborough's small, but adequate, bus station.

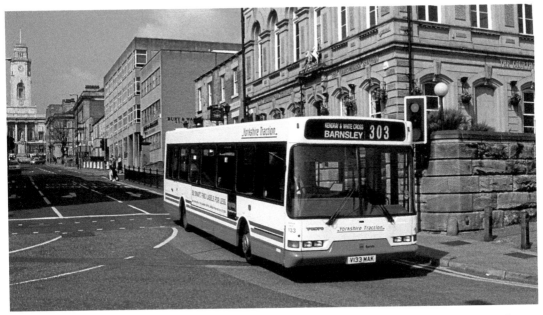

In 2000, Yorkshire Traction purchased twelve new Volvo B6BLE low-floor buses with forty-one-seat East Lancs bodies. One of them, No. 133 (V133 MAK), was found in Barnsley in March 2001, with the town's impressive town hall looking down on proceedings from the left background.

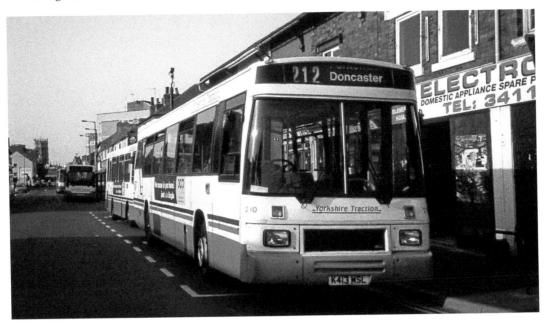

K413 MSL had been new to Tayside Regional Transport in Dundee as No. 113. This 1993-built Scania N113CRB/East Lancs bus later became Yorkshire Traction No. 210 and is seen in its new guise in Doncaster in September 2003. The location is West St Sepulchre Gate, which was being used as a temporary terminus while the town's new interchange and Frenchgate Centre were being constructed. (Jim Sambrooks)

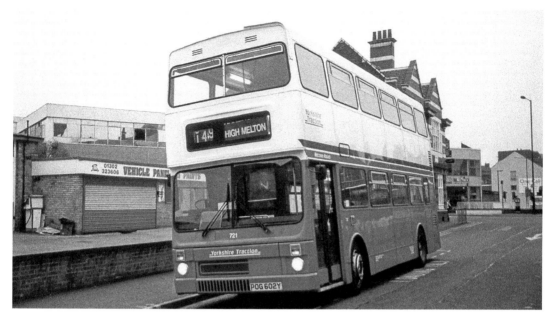

Yorkshire Traction purchased over twenty Mark II MCW Metrobus double-deckers from Travel West Midlands. This seventy-three-seat bus had been new as No. 2602 to West Midlands PTE in 1983. In its new guise as 'Tracky' No. 721, POG 602Y was found parked up in West St Sepulchre Gate, Doncaster, in June 2003. (Jim Sambrooks)

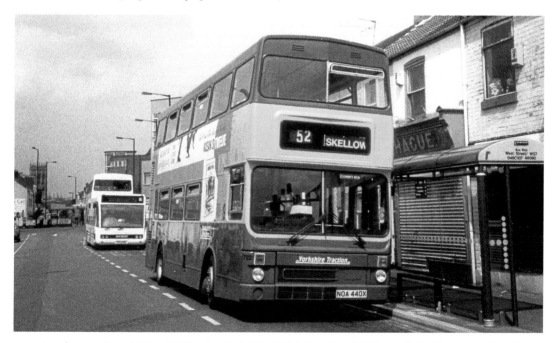

Another ex-Travel West Midlands Mark II MCW Metrobus, NOA 440X had been purchased by Yorkshire Terrier – by then a 'Tracky' subsidiary – in 2002. After being withdrawn from schools duties by that operator, it had passed to the parent company by July 2005, when it was photographed in West St Sepulchre Gate, Doncaster.

One type of chassis not yet seen in this publication is the MAN 14.220, of which eleven were purchased, all with East Lancs 'Mylennium' bodies. A forty-one-seat dual-purpose example, No. 222 (YT03 AYG), is illustrated here, sitting alongside Volvo B6LE/East Lancs No. 127 (S127 WKY) in Barnsley bus station in mid-2003.

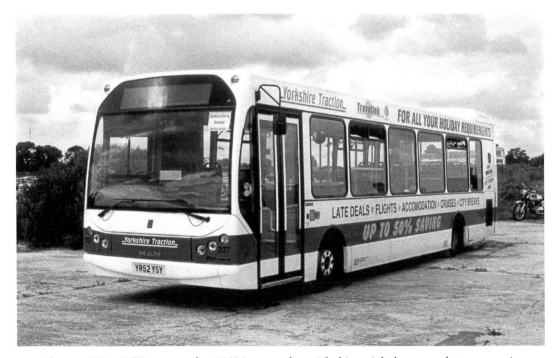

No. 227 (YR52 YSY) was another MAN 14.220, but with thirty-eight bus seats that were again in an East Lancs 'Mylennium' body. It is seen on an outing to the Sandtoft Gathering in July 2003, advertising the company's holiday tours.

Service Vehicles

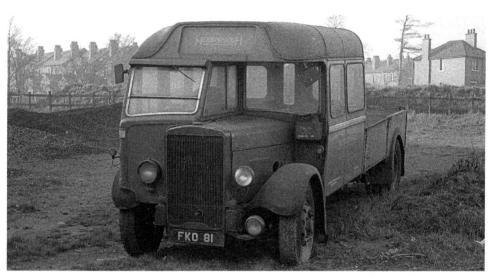

No major bus company is complete without a small number of vehicles for purposes other than carrying passengers, such as driver training, towing, etc. Often these have been converted from buses that have previously been in the main fleet, providing a much longer lifespan than the normal twelve to fifteen years of the average bus. Mexborough & Swinton's towing vehicle in the 1960s was this fine old Leyland Tiger TS8, registered FKO 81. It had been new in 1939, with an ECW thirty-five-seat body, to Maidstone & District as No. SO739. Upon purchase in 1955 it became No. 90 in the Mexborough fleet and is seen in its cut down state at Rawmarsh depot in the 1960s.

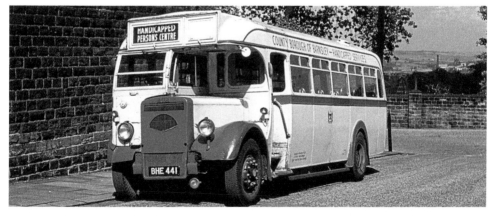

Not strictly speaking a service vehicle, but operated on behalf of the County Borough of Barnsley, was BHE 441. It had been adopted for the carriage of handicapped persons, but was based at Yorkshire Traction's Barnsley depot and driven by the company's drivers. This Leyland Tiger PS1 had been new to 'Tracky' in 1949 as No. 780. Originally fitted with a thirty-two-seat Northern Coachbuilders body, it had been converted for its later duties and is seen above Barnsley town centre on 25 July 1963. (Les Flint).

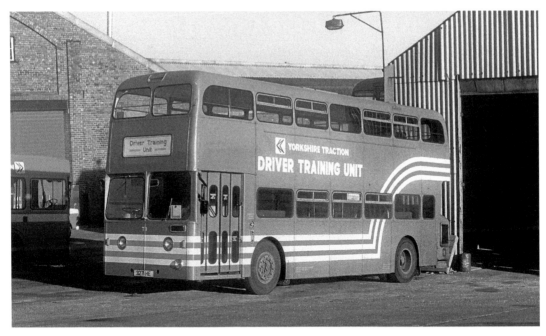

'Lowbridge' Leyland Atlantean PDR1/1 of 1964 vintage with Weymann bodywork, No. 1271 (3271 HE) gained a new lease of life as a training vehicle, numbered T1. It gained a rather garish livery, as seen in this photograph taken at Upper Sheffield Road depot in Barnsley in 1979.

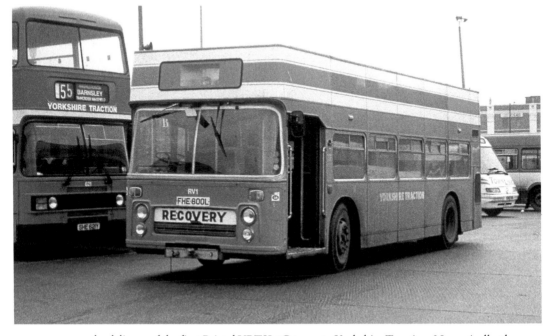

1973 saw the delivery of the first Bristol VRTSL6G types to Yorkshire Traction. Numerically, the first of the batch was No. 800 (FHE 800L), which had a seventy-eight-seat ECW body. It later became a driver training bus, but by early 1992, when this photograph was taken in Barnsley bus station, it had been cut down to become a recovery vehicle, numbered RV1.

Yet More Takeovers

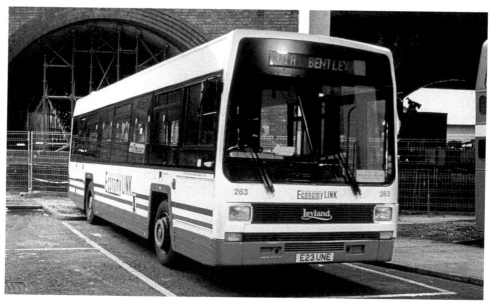

North West England bus and coach operator Shearings introduced stage carriage services in the Barnsley area in 1988. Various vehicles were used on these routes, including Leyland Atlanteans and Mark 2 Leyland Nationals. The Shearings operation was taken over by 'Tracky' in September 1991, with eight Leyland Lynx saloons being included as part of the deal. Surprisingly, these never operated in Barnsley until they became Yorkshire Traction property. No. 283 (E23 UNE) is seen in full 'Tracky' livery at Doncaster's North bus station in early 1992.

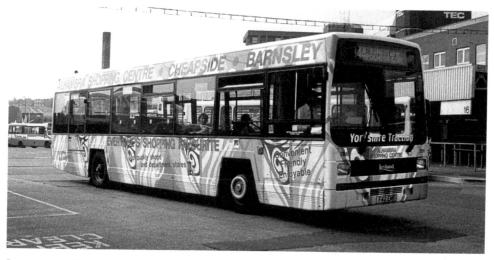

In 1995, ex-Shearings Leyland Lynx No. 286 (F42 ENF), a forty-nine-seat saloon, is seen in Barnsley bus station while advertising the town's Alhambra shopping centre.

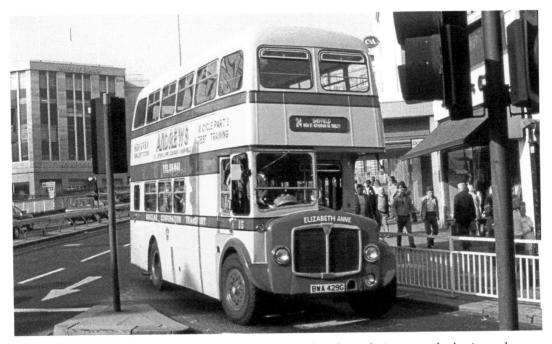

Andrew's began as a PSV driver training company, but deregulation gave the business the opportunity to branch out into stage carriage operation. A most unusual vehicle to be used on these duties was BWA 429G. Named *Elizabeth Anne*, this 1968-built AEC Regent V/Willowbrook bus had been new to Douglas Corporation, Isle of Man, as No. 15 (410 LMN), and was still carrying a version of that livery when photographed in central Sheffield in autumn 1988.

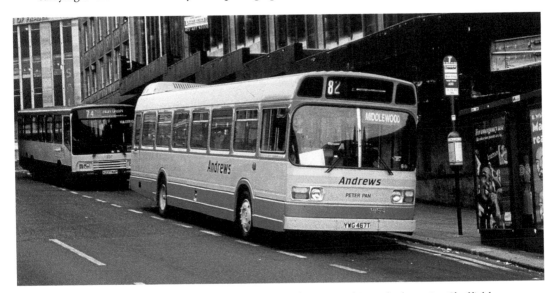

The privatised Yorkshire Traction Company wanted to expand into the lucrative Sheffield area, and so, in 1992, purchased the Andrew's business. Some 'Tracky' buses were transferred out of the main fleet and painted into the bright blue and yellow livery. One such vehicle, a Leyland National named *Peter Pan*, is seen in the centre of Sheffield in late 1993. YWG 467T had been new as a fifty-two-seater numbered 467 in the main fleet.

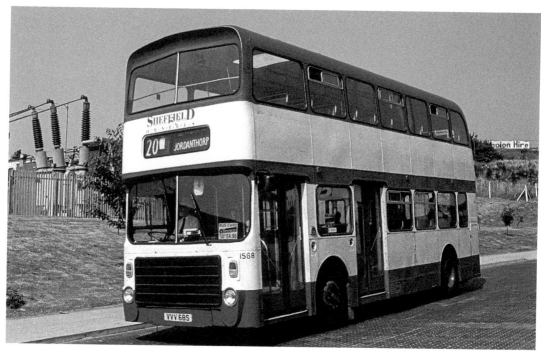

Another post deregulation independent to be purchased by Yorkshire Traction was Sheffield Omnibus Company. A few months prior to the sale, No. 1568 (VVV 68S) is seen departing from Meadowhall Interchange in July 1994. This Bristol VRT/SL3/6LXB, with dual-doored Alexander bodywork, had been new to Northampton Transport in 1977. At one time, Sheffield Omnibus Company had also run competitive services in Nottingham.

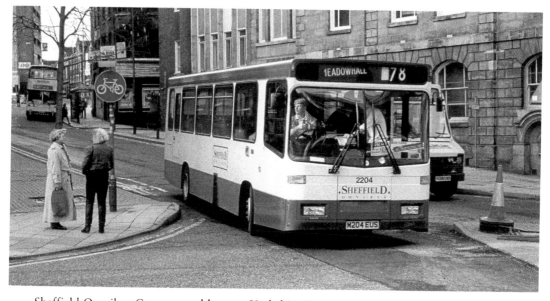

Sheffield Omnibus Company sold out to Yorkshire Traction in 1995. In the early months of that year, No. 2204 (M204 EUS) is seen in Fitzalan Square, Sheffield. This Volvo B6-50 with forty-seat Alexander 'Dash' bodywork had been new to the company in January.

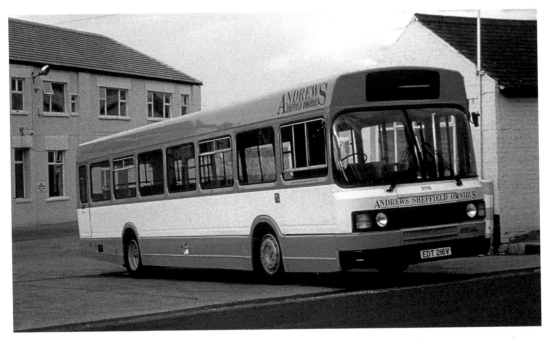

By the summer of 1995, when this photograph was taken, Sheffield Omnibus Company and Andrew's had been combined and No. 2016 (EDT 216V) had been newly painted in the revised colour scheme at Yorkshire Traction's main workshops, Upper Sheffield Road, Barnsley. This fifty-two-seat Leyland National 2 had been new to 'Tracky' as No. 216 in 1980.

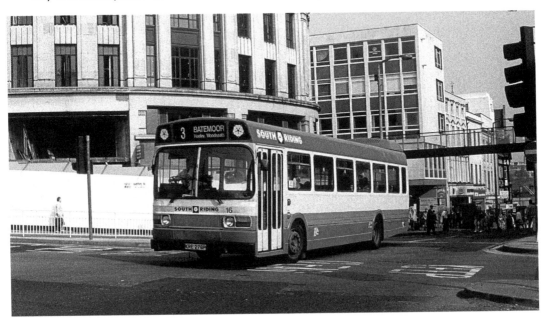

Another small Sheffield operator, South Riding, was bought out by Yorkshire Traction in 1994. The company had operated a small fleet of second-hand Leyland Nationals, one of which, No. 16 (KRE 276P), is seen exiting Shude Hill in the centre of the city in spring 1993. This bus had been new as a fifty-two-seat bus in 1975 with Potteries Motor Traction.

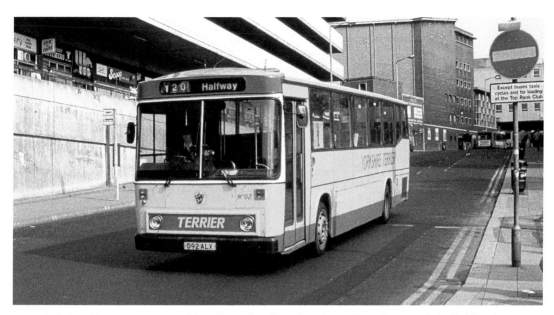

Yorkshire Terrier was a sizeable independent based in the Holbrook area of Sheffield and ran several city services. An interesting fleet was maintained, as illustrated by No. 92 (D92 ALX). This unusual Scania K112CRB with East Lancs dual-purpose bodywork had been new to British Airways as fleet number CC432 in 1987. It had retained its comfortable seating when photographed passing Pond Street bus station in Sheffield in spring 1993. After takeover by Yorkshire Traction in 1995, this vehicle was rebodied and given an extension to its life.

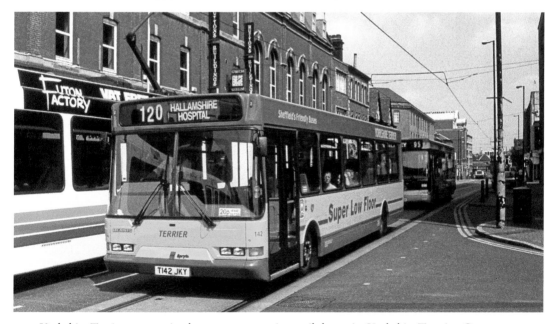

Yorkshire Terrier was retained as a separate entity until the entire Yorkshire Traction Group was bought out by Stagecoach. Yorkshire Traction upgraded the fleet with modern vehicles, such as No. 142 (T142 JKY), a Dennis Dart SLF with East Lancs forty-seat bodywork. It is seen running along the tram tracks in West Street, Sheffield, in the summer of 1999.

Barnsley & District Revived

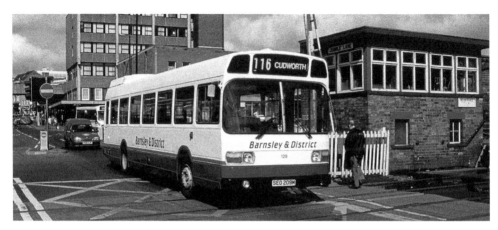

During the second half of the 1980s, competition in the Barnsley area had become an increasing problem for Yorkshire Traction. One of the largest of the new order of independent operators competing for business was Tom Jowitt, who commenced stage carriage services in 1988. He sold the entire operation to Yorkshire Traction in 1990, including the depot and vehicles. 'Tracky' retained the company as a separate entity, renaming it Barnsley & District. Leyland National SEO 209M was one of the buses included in the sale. It had been new to Barrow Corporation in 1974 as No. 8. Here it is in mid-1996 as Barnsley & District No. 128, crossing the level crossing on Jumble Lane, Barnsley. SEO 209M later went into the hands of preservationists.

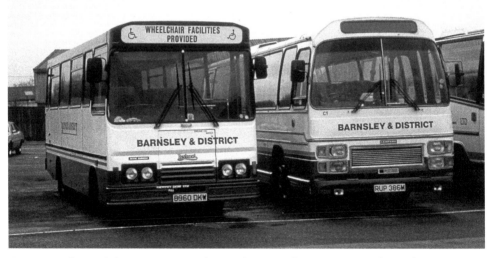

One reason for Yorkshire Traction purchasing the Jowitt business was to obtain that company's council contracts for vehicles fitted out for disabled people. At Barnsley & District's Smithies depot in early 1992 is B960 DKW, a Reebur-bodied Leyland Cub fitted with a wheelchair lift. It had been new to Jowitt, unlike the coach alongside – No. C1 (RUP 386M), a modified Leyland Leopard/Plaxton that had been new to Trimdon Motor Services in County Durham.

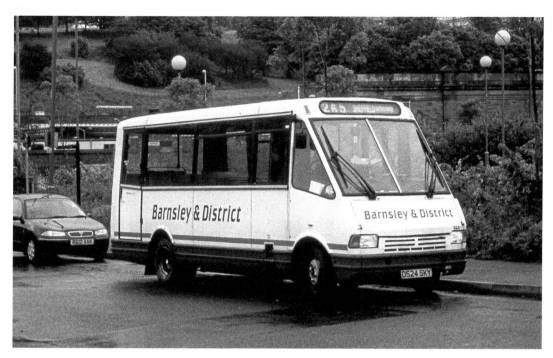

Twenty-three-seat MCW Metrorider D524 SKY had been new to Yorkshire Traction as No. 524 in 1987. By mid-1998, when it was photographed beside Sheffield's Pond Street bus station, it had been transferred to Barnsley & District and had become No. 144.

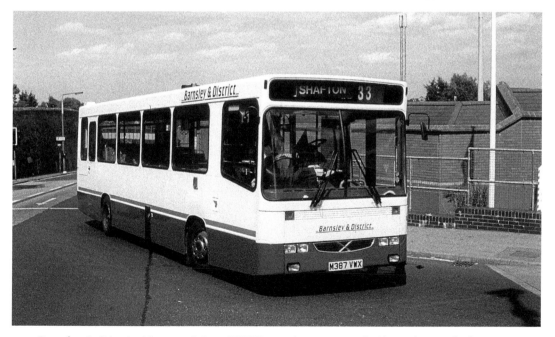

Barnsley & District No. 180 (M387 VWX), a Volvo B6-50 with Alexander 'Dash' forty-seat bodywork, had been new to Harrogate & District in 1995. By August 2003 it had passed to its new owner and was photographed when about to enter Barnsley bus station.

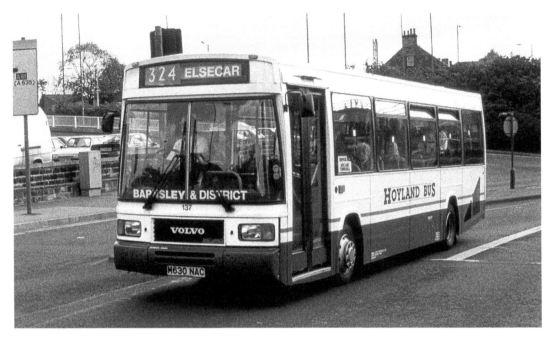

Another second-hand purchase of a Volvo B6-50 was that of No. 137 (M630 NAC). With its East Lancs forty-seat bodywork, it had been new as a demonstrator with Volvo in Warwick. Carrying 'Hoyland Bus' lettering, it is seen close to Barnsley bus station in mid-1996.

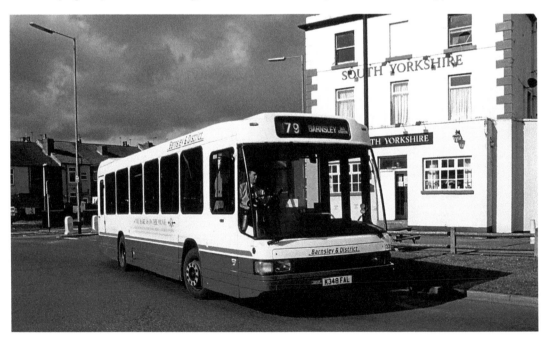

Barnsley & District No. 320 (K348 FAL) was one of several DAF SB220/Opare 'Delta' saloons purchased from Trent Motor Traction. It is seen passing the South Yorkshire Hotel (named after the South Yorkshire Railway – the company's workshops were nearby) in Mexborough in October 2005. No. 320 survived the Stagecoach takeover to become No. 26057 in that fleet.

Stagecoach Days

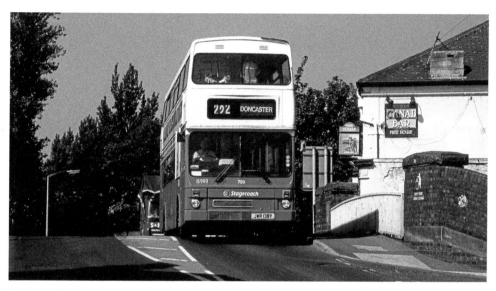

Stagecoach took over the Yorkshire Traction business in December 2005. The corporate fleet name was soon applied to the bus fleet, though the introduction of the national numbering scheme was a bit sporadic to start with. Both the 'Tracky' and the new five-figure number are visible on this Mark II MCW Metrobus, registered JWR 138Y. Number 720, aka 15993, is seen crossing the canal bridge in Swinton in July 2006.

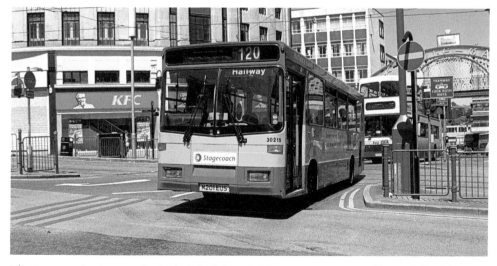

The Stagecoach takeover also included all the subsidiary operators owned by Yorkshire Traction. Still in Yorkshire Terrier colours on 3 June 2006 is what was fleet number 2201 (M201 EUS), now seen as number 30215. This Alexander 'Dash'-bodied Volvo B6-50 was photographed crossing the tramway into Fitzalan Square in Sheffield.

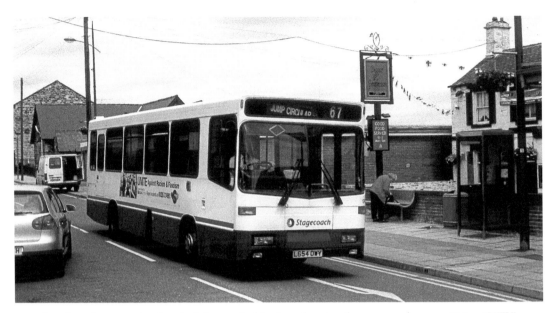

Another photograph taken in July 2006, this time showing former number 174 (L654 OWY) in Stagecoach ownership but in Barnsley & District colours while passing the Beggar and Gentleman pub in Hoyland. This Volvo B6-50/Alexander 'Dash' saloon had been new to Harrogate & District as No. 654 in 1994. It would later become 30206 under Stagecoach ownership and was later sold to Country Bus in Devon.

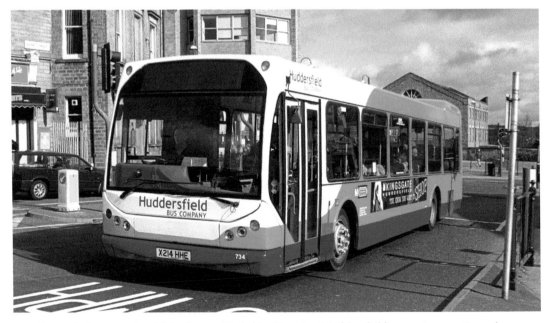

In 2008, Stagecoach sold the former Yorkshire Traction Huddersfield operations to Centrebus, a Leicestershire company with bus services in various parts of the Midlands and eastern areas of England. Part of that deal was X214 HHE, a DAF DE02 with East Lancs bodywork, new as No. 214 in the Yorkshire Traction fleet. It is seen here, arriving at Huddersfield bus station on 4 April 2009, as Huddersfield Bus Company (the brand name given by Centrebus) No. 734.

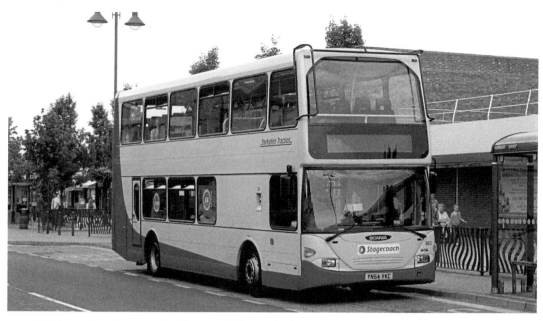

Still in its last livery of yellow and blue, which did not last long, Stagecoach No. 803 (YN54 VKC) is seen in Wombwell town centre on 27 July 2006. This Scania N94UD with East Lancs eighty-seat bodywork had been new to Yorkshire Traction in October 2004. It was later renumbered to 15413 and transferred to the Chesterfield operations of Stagecoach.

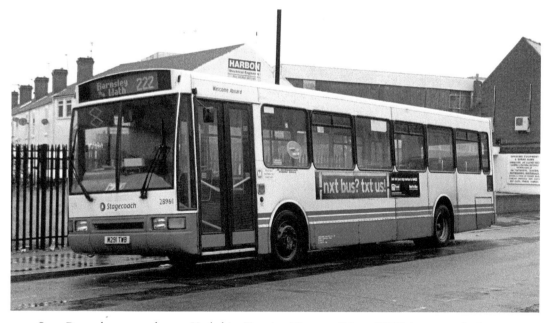

On 2 December 2007, former Yorkshire Traction No. 291 (M291 TWB) is seen under its new ownership in Doncaster, now with fleet number 28961. This Northern Counties-bodied Scania L113CRL fifty-two-seater had been new in 1994. The location is West St Sepulchre Gate, in Doncaster, where Stagecoach had a temporary office and several bus stops during the construction of the town's new interchange.

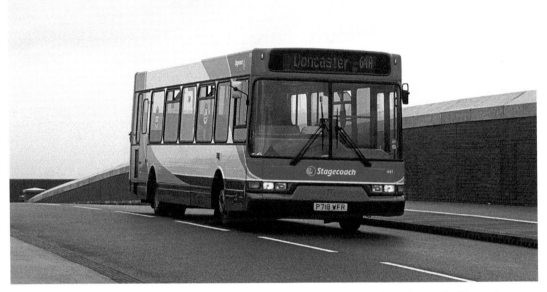

P718 WFR had originally been a demonstrator for East Lancs Coachworks in Blackburn, but had later passed to Yorkshire Traction, where it became fleet number 441. That identity is still carried on 2 September 2006, as the Dennis Dart SLF thirty-seven-seat bus, in Stagecoach livery, crosses the East Coast Main Line as it enters Doncaster via North Bridge. Once the main route into the town, North Bridge had been restricted to buses only at the time of the photograph, but other road traffic has since returned.

The settlement of Dunford Bridge once consisted of a railway station, the eastern portal of the Woodhead tunnel, the Stanhope Arms pub and a few houses. The railway has long gone and the hostelry has closed, but buses were still serving the village on 29 July 2007 as Stagecoach No. 39624 (YT03 AYJ) arrives at its turning area. This MAN 14.220 with dual-purpose forty-one-seat bodywork by East Lancs had been new Yorkshire Traction as No. 224 in 2003.

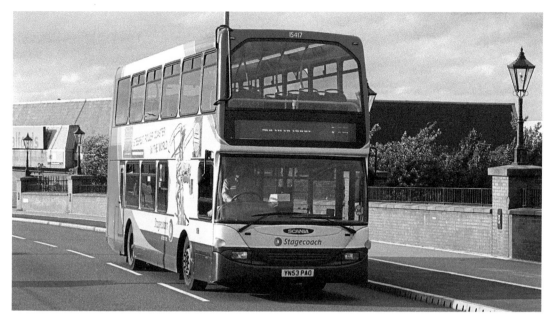

One of the last buses delivered new to Yorkshire Traction was No. 807 (YN63 PAO), a 2004-built Scania N94UD with East Lancs eighty-seat bodywork. Here it is, in full Stagecoach livery, as fleet number 15417, crossing North Bridge as it makes its way into Doncaster town centre on 5 September 2009.

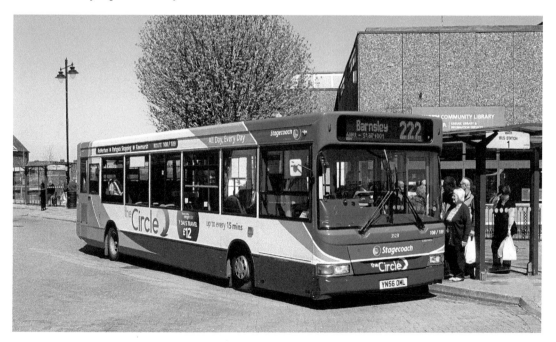

Stagecoach soon began to standardise the former Yorkshire Traction fleet, purchasing vehicles such as this Alexander Dennis Dart SLF with thirty-eight-seat Alexander Dennis (Plaxton) bodywork. No. 35231 (YN56 OML) is seen in Wath-on-Dearne town centre on route 222, despite the branding for services 108 and 109, on 20 April 2016.

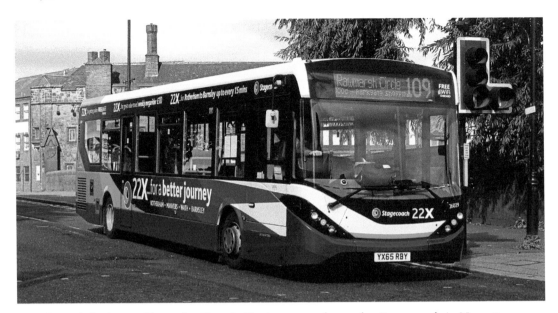

One of the latest Alexander Dennis Enviro 200 saloons for Stagecoach is No. 26029 (YX65 RBY), which is seen in a dedicated livery for route 22X from Rotherham to Barnsley while actually operating the 109 Rawmarsh Circle as it enters Rotherham on 4 September 2016. It is seen crossing the River Don by the famous Chantry Bridge, situated adjacent to the original construction with its chapel attached.

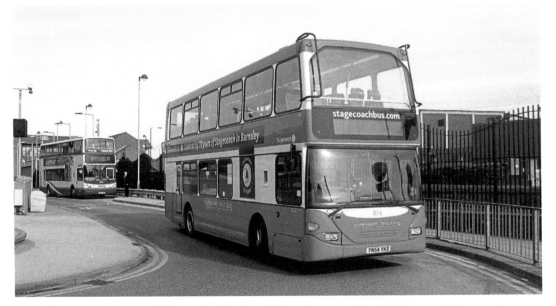

The East Lancs 'Omnidekka' style of bodywork is quite rare within the Stagecoach Group. One of only seven based in Yorkshire was No. 15414 (YN54 VKD), which was based on a Scania N94UD chassis. It was delivered in standard Stagecoach livery, but later received traditional Yorkshire Traction colours and temporary fleet number 804 in celebration of ten years of Stagecoach ownership of the company. It is seen arriving at Barnsley Interchange on 3 March 2016 and is an appropriate picture to end this publication.